THE
BENEDICTIONAL
OF
ST ÆTHELWOLD

THE BENEDICTIONAL OF ST ÆTHELWOLD

A MASTERPIECE OF ANGLO-SAXON ART

A FACSIMILE

INTRODUCED BY ANDREW PRESCOTT

THE BRITISH LIBRARY

IN MEMORY OF
PHILLIP PULSIANO
(1955–2000)

First published 2001 by The Folio Society
This edition first published 2002 by
The British Library
96 Euston Road
London NW1 2DB
Marketed in North America by
University of Toronto Press

© 2002 The British Library Board

British Library Cataloguing in Publication Data
A CIP Record for this book is available from The British Library

ISBN 0 7123 4755 0

This is a complete facsimile of BL Additional MS 49598
Digital photography by Elizabeth Hunter
Facsimile prepared for publication by Joe Whitlock Blundell
This edition designed and typeset by Bob Elliott
Printed and bound in England at the
University Press, Cambridge

INTRODUCTION

THE Benedictional of St Æthelwold is one of the most remarkable surviving products of the astonishing cultural resurgence in tenth-century England which reached its climax in the reign of King Edgar, who ruled from AD 959 to 975. This period saw the expansion and re-establishment of many monasteries which had been devastated by marauding Viking armies in the previous century, while forms of religious observance were brought into line with the latest Continental standards. Famous monastic settlements, like Ely, Thorney, Peterborough, Abingdon, Evesham and Glastonbury, were not only refounded and reformed, but received substantial landed endowments: thus, an ecclesiastic and cultural geography of England was established which would largely survive until the Reformation.

This religious upsurge was accompanied by an extraordinary flowering of cultural activities of all kinds. Not only did the Old English literature encouraged by King Alfred at the end of the ninth century continue to flourish, but a vibrant Latin literature developed which expressed its precocity through a fondness for elaborate imagery, involved grammatical formations and the use of an imposing vocabulary, often of Greek origin. Many illuminated manuscripts were produced which show, on the one hand, great expertise and sensitivity in drawing and design, and, on the other, a fondness for elaborate ornamentation, particularly the use of gold. This was also a feature of the beautiful ornaments produced to furnish the rebuilt monasteries and churches. The term 'The Golden Age of Anglo-Saxon Art', often applied to this period, reflects not only the high quality of the artistic products of the time, but also refers more literally to their great opulence and lavish use of gold in decoration. The art of the 'Golden Age' has the vibrancy and richness of a resurgent culture.

The Benedictional of St Æthelwold is the most lavishly decorated manuscript to have survived from Anglo-Saxon England. In the quantity and scale of its decoration it surpasses even the great Insular gospel books of the early Anglo-Saxon period, such as the Lindisfarne Gospels. The Benedictional contains twenty-eight full-page miniatures (probably another fifteen are missing), nineteen pages in which the text is surrounded by elaborately decorated frames (apparently another two of these have been lost), and two historiated initials, one of which is in another decorative frame. By comparison, the much more famous Lindisfarne Gospels has just fifteen fully decorated pages and sixteen pages of decorated canon tables, although, unlike the Benedictional, the Lindisfarne Gospels also contains many highly decorated initials. It is of course invidious to compare two manuscripts separated in their production by some three hundred years and belonging to completely different periods and artistic traditions. Nevertheless, this simple picture count makes it clear that the Benedictional is one of the most imposing monuments of Anglo-Saxon art.

The Benedictional is not just a great work of art; it is also a notable literary achievement. Many of the elaborate Latin blessings contained in the manuscript were of English composition, and represent a substantial corpus of Latin composition from a country in which, not very long before, King Alfred had despaired of finding a man who could understand Latin. The Benedictional seems to have helped create a trend in England for the composition of such blessings, and the episcopal blessing became one of the most distinctive products of the revived Latin culture in England. Moreover, the Benedictional was made for the personal use of one of the leaders of this movement of cultural and spiritual revival in England, St Æthelwold, who was Bishop of Winchester from 963 until his death on 1 August 984. Æthelwold himself probably took an active personal interest in the artistic and liturgical contents of the manuscript. At every point, in both its decoration and its text, the Benedictional bears vivid testimony to the ideological preoccupations of the Church in Edgar's time. In short, the Benedictional of St Æthelwold is both a magnificent

artistic achievement, an interesting product of the revived Latin culture in England, and an emblem, almost a relic, of one of the most decisive moments in the early process of the formation of the English nation.

King Alfred (who ruled from 871 until 899) defeated the Vikings and instituted defensive measures to ensure that they would never again overrun Wessex. He saw the attacks of the Vikings as a symptom of divine displeasure, and sought to revitalise learning and church life so as to ensure that God would in future protect his people. Alfred imported scholars into Wessex, and took a personal interest in the programme of cultural improvement, translating books from Latin into English. Alfred's successor Edward the Elder, who reigned from 899 to 924, built on Alfred's military success, and took control of all the land up to the Humber. He also continued his father's cultural policy. He founded the New Minster at Winchester and completed the foundation of the nunnery known as the Nunnaminster, also at Winchester. Æthelwold was born at Winchester during Edward's reign, probably between about 904 and 909. His family seems to have been wealthy and well-connected inhabitants of Winchester. Edward's son Æthelstan, who ruled from 924 to 939, continued the push north, establishing himself as King of the Northumbrians. Æthelstan was an enthusiastic collector of holy relics and books. The elevated sense of kingship which characterised Alfred's successors is reflected in the coronation order used by Æthelstan, which is the basis of the coronation service still used in England today.

Æthelwold in his youth was already of a learned and scholarly disposition. His biographer, Wulfstan, a monk and priest at Winchester, describes how he 'was naturally quick and sharp of mind, so that he did not lazily consign to oblivion what he learnt from his elder's teaching, but rather stored it in a retentive memory'. The holiness and intelligence of the young Æthelwold brought him to the attention of King Æthelstan. Wulfstan describes how the king 'had the young man sent for without delay. He was brought to the king; and standing in his presence he found favour in his sight and in the eyes of his thegns.' Wulfstan states that Æthelwold spent a long time in the king's court, as his inseparable companion, learning much from the wise men of the court. Eventually, Æthelwold was sent by the king to Ælfheah, Bishop of Winchester from 934 or 935 to 951, who ordained Æthelwold as a priest. On the same day that Ælfheah ordained Æthelwold, he also ordained his young nephew Dunstan. It was to be the beginning of a remarkable partnership.

Dunstan had been a monk at the small monastery of Glastonbury since he was in his teens. He had spent periods in the royal court when it was near Glastonbury, but his other-worldliness and love of study had earned him enemies at court, who accused him of dabbling in magic. They physically attacked him and secured his banishment from court. In despair, he had considered abandoning his monastic vocation and getting married instead. Bishop Ælfheah dissuaded him from adopting this course, and prevailed on him to be ordained. Dunstan was brought back to the royal household by a new king, Edmund, who ruled from 939 to 946, but Dunstan's enemies ensured that he was soon once again dismissed from court. To give thanks for a narrow escape in a hunting accident, Edmund determined to make reparation to Dunstan for the bad treatment he had suffered, appointing him to be Abbot of Glastonbury. Dunstan devoted all his energies to making Glastonbury a major spiritual centre. He introduced the latest forms of observance and enlarged the monastic buildings. He soon started attracting many disciples, of whom the most gifted was Æthelwold.

It was at Glastonbury that Æthelwold received the monastic habit. In Wulfstan's words, Æthelwold 'profited greatly by Dunstan's teaching, and eventually received the habit of the monastic order from him, devoting himself humbly to his rule. At Glastonbury, he learned skill in the liberal art of grammar and the honey-sweet system of metrics... He was eager to read the best-known Christian writers, and was in addition constant in his vigils and prayer, taming himself by fasting and never ceasing to exhort his fellow monks to strive for the heights.' Æthelwold became anxious to find out more about the monastic reforms then taking place in Europe, and wanted to study abroad. Æthelwold's request to leave the country was refused by King Eadred (reigned from 946 to 955), who did not want his kingdom to lose such a learned

and holy man. Instead, at the suggestion of his mother Eadgifu, Eadred made Æthelwold abbot of the dilapidated monastery at Abingdon, which had come into royal hands.

Under Æthelwold, Abingdon grew into a 'glorious minster'. One of his first actions was to establish a school, and the future King Edgar studied there. Æthelwold's reputation for sanctity and strict observance attracted men from all over the country to follow the monastic life at Abingdon. He established contact with reformers on the Continent, and sought to ensure that observance at Abingdon was in line with the most up-to-date Continental practice. Monks from the reformed monasteries at Fleury and Corbie came to Abingdon to instruct their English counterparts in the forms of chanting. The monastery's endowments were substantially increased, particularly by gifts of royal land. A magnificent new church was built, furnished in the most sumptuous fashion. A twelfth-century description of the church states that 'the chancel was round, the church itself was also round, having twice the length of the chancel. The tower also was round.' It has been suggested that this means that the church was an aisled rotunda, recalling the royal symbolism of the palatine chapel at Aachen. Æthelwold himself is said to have built the altar table, which was made of gold and silver, decorated with the sculpted figures of the twelve apostles. It cost the enormous sum of three hundred pounds. Also attributed to Æthelwold was a gold-plated wheel which supported twelve lamps and from which were suspended little bells. Other treasures of the church included three crosses of gold and silver, each four feet in length, and texts to adorn the church made of silver and precious stones. Most of these treasures were destroyed or dispersed after the Norman Conquest.

The ecclesiastical revival suffered a setback in 955, with the accession to the throne of King Eadwig, who resented the power of Dunstan and the way in which so much landed property had been given to the Church. Dunstan fled and took refuge at the Abbey of St Peter in Ghent. Æthelwold remained at Abingdon but kept a low profile, and the monastery suffered difficulty in implementing land grants made during Eadred's reign, so that the building programme had temporarily to be scaled down. There was a revolt against Eadwig, and his younger brother Edgar became ruler of the lands to the north of the Thames. Edgar recalled Dunstan, appointing him to the bishoprics of Worcester and of London. Edgar became king of the whole country on Eadwig's death in 959, and one his first acts as ruler of the whole kingdom was to appoint Dunstan as Archbishop of Canterbury.

Edgar strongly supported Æthelwold's work at Abingdon, ensuring that it received all the lands it claimed and making further gifts. In 963 Æthelwold was appointed Bishop of Winchester. He was scandalised to find that the secular clerks who staffed the Old and New Minsters at Winchester, in Wulfstan's words, 'involved in wicked and scandalous behaviour, victims of pride, insolence and riotous living to such a degree that some of them did not think fit to celebrate mass in due order. They married wives illicitly, divorced them, and took others; they were constantly given to gourmandising and drunkenness.' This was completely unacceptable to the new bishop, and, in 964, with the king's support, Æthelwold forcibly expelled the old canons, and replaced them with monks from Abingdon. Wulfstan describes how, when the canons were expelled from the Old Minster, Æthelwold was supported by Wulstan of Dalham, one of the most well-known of members of the royal household, who ordered the canons in the name of the king to either hand over the minster to the monks or become monks themselves. 'Stricken with terror and detesting the monastic life, they left as soon as the monks entered. Still, three of them were converted later . . .'

Such ruthless action in pursuit of introducing new standards of religious life earned Æthelwold enemies, and there was afterwards at least one attempt to murder him. According to Wulfstan, the expelled canons plotted to poison Æthelwold and recover their old places. They poisoned Æthelwold while he was entertaining guests in his own hall. He managed to stagger to his bed, but became completely paralysed. He was determined to overcome the effects of the poison by remembering his Christian faith. By bringing to mind declarations of Christ, such as his assurance that 'if believers drink any deadly thing, it shall not hurt them', Æthelwold found that the pain and paralysis caused by the poison gradually disappeared. He returned to the hall showing no signs of his terrible experience. The canons, recognising that they could not defeat Æthelwold, fled.

Æthelwold's campaign to revive the monastic life of England soon extended beyond Wessex; as Wulfstan put it, he 'was concerned to bring monks together in the service of Almighty God not only within Wessex but also in remote parts of Britain'. He revived the three great monasteries of eastern England, Peterborough, Ely and Thorney, and assisted in the reform of houses elsewhere, including probably St Neots in Cambridgeshire and Chertsey in Surrey. One problem that the reformers encountered was the use of different versions of the Benedictine rule. The king ordered a great council to be held at Winchester and urged it to ensure that 'all be of one mind as regards monastic usage . . . lest differing ways of observing the customs of one rule and one country should bring their holy conversation into disrepute'. The result was the *Regularis Concordia* ('Agreement of the Rules' or 'Monastic Agreement'), which gave detailed guidance on the liturgical and other practices to by followed by all English monasteries. It seems that Æthelwold was the main compiler of this important document.

The programme followed by Æthelwold at Winchester and by his followers at the new monastic foundations was very much that developed at Abingdon. The landed endowments of each of the foundations were built up by securing royal grants, taking legal action to recover property which had been alienated, and creating comprehensive documentary records of land ownership. Elaborate stone churches and monastic quarters were built, most notably at Winchester, where the extensions to the Old Minster included a spectacular westwork, which has been described as 'one of the architectural wonders of the Anglo-Saxon kingdom'. The churches were richly decorated with furnishings of gold and silver, although sadly no major pieces survive. Æthelwold was particularly preoccupied with the modernisation of the liturgy. At Abingdon, he had brought monks over from leading reform monasteries in Europe to instruct the monks in chanting, and at Winchester a number of innovative musical techniques were introduced. Scholarship was also very important. Winchester became a centre of Latin scholarship, using the very florid and ostentatious style of composition known as hermeneutic style. Æthelwold also wrote in Old English, producing a translation of the Rule of St Benedict and glosses on the psalter and other Latin works.

Although Dunstan as Archbishop of Canterbury remained a very powerful force in the overall ecclesiastical and cultural programme of Edgar's reign, it seems that it was Æthelwold who was closest to the king. It has been suggested that, during the period before he became bishop, Æthelwold had been in the king's personal service, writing and drafting charters and advising on policy. As Barbara Yorke has observed, ' . . . many of Æthelwold's ecclesiastical concerns had an overt political dimension as well, and appear to have been designed to elevate the office of the king. The stress on the king's role in the *Regularis Concordia*, the political symbolism of the westwork and some of the imagery in the Benedictional, all point in this direction, and raise questions about Æthelwold's role in key events of Edgar's reign, such as his second coronation at Bath in 973 with its imperial connotations.' Edgar's coronation in 973 marked the ideological highpoint of his reign. The rite used emphasised the imperial nature of Edgar's power and celebrated his authority over all England. The ceremony took place in Bath, which was possibly meant to suggest a continuity between Edgar and those Romans who built the town. But the ceremony was not purely concerned with Edgar's temporal power; it also emphasised the sacred nature of his office, and suggested parallels with an episcopal consecration. The ceremony was the supreme public expression of the cultural and ideological programme developed by Dunstan, Æthelwold and their associates with Edgar's active support and patronage. It is a programme which is strongly echoed at many points in the Benedictional.

Edgar died in 975. His son, Edward, was murdered after reigning for just three years, and the ten-year-old Æthelred succeeded to the throne. One of the young king's leading advisors was Æthelwold whose death on 1 August 984 led to a major shift in the alignments of the court. The loss of Æthelwold's staunch and wise advice afterwards helped earn Æthelred the title of 'the Unready' or 'without good counsel'. Æthelwold was at first buried in the crypt of the Old Minster, where, Wulfstan declared, the bishop had received a heavenly sign that he should be laid to rest. Not surprisingly, within a short time there were reports of miracles at Æthelwold's tomb. In one of these, in which an inhabitant of Wallingford had his blindness cured following a vision of Æthelwold, Wulfstan himself was apparently involved. Æthelwold's

remains were removed in 996 to a more sumptuous tomb in the choir of the church, where reports of miracles continued. At this time, canonisation did not require formal papal or episcopal approval; sainthood was achieved by local commemoration. Following the translation of his remains, Æthelwold began to be commemorated as a saint in the liturgy at Winchester, spreading from there to other Winchester houses and monasteries which had a special connection with the saint, such as Ely, Thorney and Peterborough.

The Benedictional is just one small part of all the artistic, literary and spiritual activity associated with Æthelwold, but it gives us a hint of how glorious Æthelwold's churches at Abingdon, Winchester and elsewhere must have been. We know about the Benedictional's connection with Æthelwold because of a poem at the beginning (folios 4v–5):

A bishop, the great Æthelwold, whom the lord had made patron of Winchester, ordered a certain monk subject to him to write the present book – truly knowing well how to preserve Christ's fleecy lambs from the malignant art of the devil; illustrious, venerable and benign, he desires also to render, as a steward, full fruit to God, when the judge who sifts the actions of the whole world, what each has done, shall come and give reward as they deserve, to the just eternal life, and punishment to the unjust. He commanded also to be made in this book many arches well adorned and filled with various figures decorated with manifold beautiful colours and with gold. This book the Boanerges aforesaid[1] caused to be indited for himself in order that he might be able to sanctify the people of the Saviour by means of it and to pour forth holy prayers to God for the flock committed to him, and that he may lose no little lambkin of the fold, but may be able to say joyfully, 'Lo, I present to thee myself and the children whom thou didst give me to keep; by thy aid none of them has the fierce ravening wolf snatched away, but we stand together and desire to receive abiding life and to enjoy it in the heavens with the supreme sovereign whose members we are, who by right is the head or salvation of those baptised in the clear-sounding name of the Father and the Son and of the Holy Ghost so that, if they wander not astray but hold the faith, and by their deeds also perform the commands of salvation and repel all heresy from their hearts, ever striving to overcome the evil of sin, they may be joined to the Lord in heaven without end. May Christ the Saviour, who is the good king of the world, mercifully grant this to all who are sprinkled with holy baptism; and to the great father who ordered this book to be written may he grant an eternal kingdom above. Let all who look upon this book pray always that after the term of the flesh I may abide in heaven – Godeman the writer, as a suppliant, earnestly asks this.[2]

This poem thus tells us that the Benedictional was made at Æthelwold's express command for his personal use, and that he took a personal interest in the scheme of decoration. It also tells us the name of the scribe, Godeman. He was a monk at the Old Minster in Winchester, perhaps one of the monks from Abingdon who were introduced there by Æthelwold in 964. He was clearly one of Æthelwold's most devoted and gifted followers. Æthelwold appointed Godeman as abbot of the revived East Anglian monastery of Thorney, which he refounded between 971 and 973 (the exact date when Godeman became abbot is not known). Godeman's hand can also be found in some other manuscripts, including a fragment of a Gospel Book (London, College of Arms, MS Arundel 22, ff. 84–85), and the first part of the 'Ramsey' Benedictional (Paris, Bibliothèque Nationale, MS. Lat. 987). The 'Ramsey' Benedictional is so called because of a suggestion that it should be identified with a manuscript recorded as having been sent from Ramsey to Fleury abbey at the beginning of the eleventh century, but there is no evidence to support this. The text of the 'Ramsey' Benedictional is very closely related to that of the Benedictional of St Æthelwold. The 'Ramsey' Benedictional contains fewer and cruder miniatures than the Benedictional, and one possible interpretation of the relationship between the two is that Godeman produced 'Ramsey' first and, when he showed it to Æthelwold, the bishop instructed him to prepare a fuller and more sumptuous version. However, other possible interpretations of the relationship between the 'Ramsey' Benedictional and the Benedictional of St Æthelwold have been suggested, and much further investigation is required.

[1] i.e. Æthelwold. Boanerges is the Greek version of the name given by Christ to the sons of Zebedee, deriving from the Hebrew or Aramaic term meaning 'sons of thunder', and is hence applied to a powerful or vociferous preacher or orator.

[2] Translation taken from *The Benedictional of St Æthelwold, Bishop of Winchester 963–984*, ed. G. F. Warner and H. A. Wilson (Oxford: The Roxburghe Club, 1910)

It is not clear whether Godeman was also the artist as well as the scribe of the Benedictional, but, given the way in which Æthelwold and Dunstan were apparently artists and craftsmen as well as scholars, it seems reasonable to assume that Godeman was also the artist of the manuscript. Various dry-point notes in the margins (folios 27, 27v, 58v, 60–63v, 104, 105, 106), recently discovered by Professor William Schipper, show Godeman struggling with the order of the text and trying to ensure that the manuscript was compiled in the proper order. References in the text of the Benedictional to miracles at the shrine of St Swithun suggest that the manuscript was executed sometime after Æthelwold moved Swithun's remains to a new shrine in 971. This indicates that the manuscript was executed between 971 and Æthelwold's death in 984 (probably towards the beginning of this period, in view of Godeman's appointment to Thorney).

Professor Schipper has pointed out that the focus of scholarly attention on the Benedictional has been either on the decoration or the text; there has been little work on how the manuscript was put together. Nevertheless, as Professor Schipper has pointed out, there are many clues as to how Godeman proceeded. They suggest a surprising degree of experimentation and improvisation in preparing the vellum codex. The opening folios include an inverted frame for the opening of a blessing as well as some pen trials for drawings of drapery (f. 4). Clearly Godeman felt he could not waste vellum, and was unwilling to throw away spoiled sheets. Was this because of the cost of vellum, or did Godeman find it difficult to organise his materials? Likewise, in pricking holes and ruling lines to guide his handwriting, Godeman again frequently made mistakes. He did not dispose of the vellum, but inserted correct rulings and new sets of guide holes. The most important evidence as to the construction of the manuscript identified by Professor Schipper are the dry-point notes on folios 27–27v, 58v, 60–63v, and 104–106. These comprise notes of the opening words of blessings or headings for different feasts. Some occur on different pages to those where the actual blessing is found; one (St George on f. 61v) apparently relates to a blessing which is not in the final text. Clearly Godeman was still in the process of arranging his text and trying to lay it out on the manuscript pages, but exactly what these notes tell us about his procedure is not clear.

There is clearly sufficient evidence to tell an interesting story about the compilation of the Benedictional, but a great deal more research is necessary before that story can be told. Not only does the sometimes puzzling evidence found by Professor Schipper require closer examination, but it is above all necessary to undertake further study into the relationship of the Benedictional to other manuscripts, above all the 'Ramsey' Benedictional.

A benedictional is an unusual type of service book. It is a collection of solemn blessings for the use of bishops. It is closely related to a pontifical, a type of liturgical book containing rites which could only be celebrated by a bishop, and indeed many benedictionals are found as sections of a pontifical. Blessings are, of course, used in many different church services, but those in benedictionals were mainly intended to be pronounced by the bishop at mass, just before the communion. Pre-communion blessings first began to appear in the liturgy in the fourth and fifth centuries. Their purposes was, in the words of one early Eastern liturgy, that 'we may be made worthy to take communion and share in thy mysteries'. In sixth- and seventh-century Spain and France, pre-communion blessings reached a highly-developed form and became a very distinctive feature of the Gallican liturgy. During the eighth century, the Gallican liturgy became increasingly subject to Roman influence, with Roman service books displacing Gallican forms. These Roman service books, however, did not make any provision for pre-communion blessings. There was a reluctance to abandon such a particularly popular liturgical practice, and various attempts were made to produce collections of blessings for use with the Roman books, leading to the emergence of two main forms of Gallican benedictional in the eighth century, known as the 'long' and the 'short' types.

The Emperor Charlemagne was anxious to ensure liturgical conformity in his dominions, and he asked Pope Adrian to send a service book which would establish the official Roman form of service. The sacramentary sent by the Pope, which became known as the *Hadrianum*, supposedly embodied the liturgy as set down by Pope Gregory the Great in the sixth century. There were a number of omissions in this service book, however, and again it did not include pre-communion blessings. In the early ninth century, the

ecclesiastical reformer Benedict of Aniane produced a supplement to the *Hadrianum* containing much of the missing material, including a short benedictional apparently composed by Benedict himself, which became known as the 'Gregorian' benedictional. The first benedictionals to survive from England, dating from the beginning of the tenth century, are in this 'Gregorian' form. The Benedictional of St Æthelwold is apparently a deliberate attempt to create a synthesis of the two main forms of benedictional, the 'Gallican' and the 'Gregorian'. It combines together, in a very systematic and skilful fashion, two almost complete benedictionals: a Gregorian benedictional and a version of the long Gallican benedictional. For major feasts, the Benedictional of St Æthelwold usually gives a Gregorian blessing first then a Gallican alternative. In addition to this Continental material, the Benedictional of St Æthelwold also includes a number of blessings which occur only in English manuscripts or those closely related to English traditions. It has been suggested that at least one, the blessing for the feast of St Æthelthryth, was the work of Æthelwold himself. This hybrid form of benedictional was extremely influential. It was known abroad within a short time of its compilation and seems to have instigated a wave of benedictional compilation in England itself. These benedictionals treat the hybrid text found in the 'Ramsey' Benedictional and the Benedictional of St Æthelwold in a variety of ways, but all bear testimony to the enormous influence of these two manuscripts.

The characteristic textual structure of these benedictionals, with the combination of different Continental traditions as well as the inclusion of a substantial amount of English material, is echoed in other products of the monastic revival in England. A parallel which immediately springs to mind is the *Regularis Concordia*, attributed to Æthelwold himself. This again draws together different Continental traditions, whilst adding a substantial English element. It has been argued that the origins of the *Regularis Concordia* lie in a Continental compilation, but it is nevertheless clear from the preface that Æthelwold was aware of, and approved, its eclectic character, stating that it drew together all the best practices, 'even as honey is gathered together by bees from all manner of wild flowers and collected together into one hive'. Other interesting parallels to the Benedictional occur in the famous Winchester tropers, which, although they were produced after Æthelwold's death, were based on the liturgical and musical practices established at Winchester in his time. Unlike many tropers, the Winchester tropers are extremely clear and rational in their structure, a quality they share with the Benedictional. Again, the Winchester tropers consist essentially of a combination of different Continental traditions, this time French and German. Moreover, the tropers also include, like the benedictionals, a substantial number of English forms.

The text of the Benedictional, then, appears, like many other products of the tenth-century monastic revival, to represent a self-conscious attempt to synthesise different continental traditions, whilst at the same time confirming and strengthening local practice. This eclectic outlook is apparent not only from the text but also in the artistic programme of the manuscript. Even the handwriting is intended to make an ideological point. The elegant Caroline Minuscule script shows a scribe attempting to emulate the latest European practice, and rejecting the archaic-looking Square Minuscule script favoured in the earlier part of the century. Like the text, the miniatures draw together different traditions. Much of the inspiration for the iconography and design of particular scenes is Carolingian, but this has been fused with material drawn from Byzantine traditions and into the whole are injected many innovative English components. This process is succinctly described by Robert Deshman: 'The forms of figural style, ornament, and script found in Anglo-Saxon manuscripts ante-dating the reform were deliberately suppressed, apparently because they were associated with the earlier decadence of religious life. Replacing them were the more Mediterranean styles from abroad that seem to have carried ideological connotations of the reformed Continental religious practices that Æthelwold and the other monastic leaders introduced into England. These imported figural and ornamental styles were recast according to old Insular decorative principles, perhaps to evoke the ideal of early Insular monasticism that Æthelwold sought to emulate in his own era.'

This process of fusion was not purely stylistic. The iconography of the miniatures draws on a mixture of Carolingian and Byzantine antecedents, whilst also adding many distinctive Anglo-Saxon touches. Many

of the iconographical innovations recall the English ecclesiastical reform programme. In particular, the stress on Christ's divine kingship is clearly meant to help elevate the status of the earthly king, Edgar, on whom the reform movement relied and whose status the reformers in turn exalted. Perhaps the most fascinating aspect of the Benedictional is the way in which it acts as a testimony to the ideology of the great tenth-century ecclesiastical revival, illustrating how a work of art can be a very eloquent historical document. In this sense, the most important feature of the Benedictional is that it was a book made for a bishop to assist him in his pastoral duties. It is a reminder that, although the reform movement promoted the monastic life, it was pushed through by bishops like Æthelwold, Dunstan and Oswald. The Benedictional was a crook provided to the shepherd of the people of the diocese of Winchester 'to pour forth holy prayers to God for the flock committed to him, and that he may lose no little lambkin of the fold'.

Godeman was a monk of the Old Minster at Winchester, and it seems likely that the Benedictional was executed there. After Æthelwold's death, the manuscript remained either in Winchester Cathedral or Hyde Abbey (as the New Minster became) until the Reformation. Fragments of a fifteenth-century inventory of Hyde Abbey in the binding show that it was still in Winchester at that time. After the Reformation, the manuscript came into the possession of Henry Compton, Bishop successively of Oxford and London, who died in 1713. It then passed to his nephew and executor, General Henry Compton, who gave the book to the Duke of Devonshire. Humfrey Wanley tried to acquire the manuscript in the 1720s for the library of Robert Harley, 2nd Earl of Oxford, but the Duke was reluctant to part with the manuscript without General Compton's permission, and it remained one of the treasures of the Dukes of Devonshire in their house at Chatsworth in Derbyshire until 1957, when it was acquired by the British Museum. (It was transferred to the custody of The British Library on its creation in 1973.) In 1984, the millennium of the death of St Æthelwold, it formed the centrepiece of a major exhibition jointly organised by the British Museum and The British Library, *The Golden Age of Anglo-Saxon Art*.

A GUIDE TO THE MANUSCRIPT

THE beauty of the Benedictional of St Æthelwold has captivated students of Anglo-Saxon life and culture for nearly three centuries, and they have sought in different ways to record the luxuriant decoration of this manuscript. In 1720, Humfrey Wanley, frustrated in his attempts to obtain the manuscript from the Duke of Devonshire for the Harleian Library, commissioned the distinguished artist George Vertue to make a drawing of it. In 1832, the manuscript was brought to London and exhibited before an enraptured Society of Antiquaries. A learned account of the manuscript was given to the Society by John Gage Rokewode (1786–1842). Rokewode was best known for his work on the history of Suffolk (his edition of the chronicle of the Bury monk Jocelin of Brakelond inspired Thomas Carlyle's *Past and Present*), but he also had a profound interest in medieval art, exhibiting to the Society of Antiquaries a number of other famous medieval manuscripts, including the Luttrell Psalter. When Rokewode's paper on the Benedictional of St Æthelwold was published in the journal of the Society of Antiquaries, *Archæologia*, it was accompanied by thirty-two plates illustrating the manuscript, a pioneering attempt to represent on a large scale the contents of an illuminated manuscript, but these engravings consisted mostly of line drawings, and convey little of the beauty of the manuscript.

Scholars had to make do with these crude engravings until the advent of photography made the production of a full facsimile of the manuscript more practicable. In 1910, a photographic facsimile of the

manuscript was published, prepared under the direction of the energetic Keeper of Manuscripts at the British Museum, Sir George Frederic Warner (1845–1936), who also produced facsimiles of a number of other important manuscripts, including the Sforza Hours, Queen Mary Psalter and the Guthlac Roll. The introductory material included an important study of the manuscript by Warner himself and a detailed analysis of its liturgical content by the Revd. Henry Austin Wilson (1854–1927), of Magdalen College, Oxford. This facsimile was produced using the collotype process favoured by the British Museum at this time and pioneered by Warner, with his colleague Edward Maunde Thompson. This process gave a softer and more subtle rendition of manuscript illumination than other photographic processes available at the time. Despite the great care with which this facsimile was prepared, it was nevertheless in black and white, and does not convey the subtle colouring and beautiful gold decoration of the original. Moreover, it was published for a private society, the Roxburghe Club, and has been very difficult to obtain.

Since the Benedictional was acquired by the British Museum, various illustrations from it have been reproduced in colour, most notably in *The Benedictional of St Ethelwold*, published in 1959 by Francis Wormald (1904–72), an Assistant Keeper in the Department of Manuscripts of the British Museum and afterwards successively Professor of Palaeography and Director of the Institute of Historical Research in the University of London, and in the magisterial study published in 1995, *The Benedictional of Æthelwold*, by Robert Deshman, the product of a lifetime's intensive study of, and thought about, the Benedictional. Deshman's book reproduces all the major illustrations in colour. The present volume is the first full facsimile of the manuscript to have been produced in colour. It is perhaps interesting to note that it has been prepared using digital images, and consequently marks another stage in the use of technical ingenuity to record the contents of the manuscript and increase awareness and appreciation of its great beauty.

The colour facsimile not only enables the beauty of the decorated pages to be better appreciated, but also highlights the contrast between those festivals marked in the manuscript by full page miniatures and decoration of the opening words of the blessing, and other occasions for which blessings are given, where the script is elegant but unadorned. The decoration of the manuscript would in itself have added significantly to the colour and sense of occasion when major festivals were celebrated. Unfortunately it is not feasible to give here a full translation of the text of the blessings, but some translations are included below to give a flavour of their contents.[1]

Folio 1. The Choir of Confessors

The Benedictional originally opened with a spectacular sequence of miniatures depicting Christ and then, on double pages, each of the seven choirs of saints (angels, patriarchs, prophets, apostles, martyrs, confessors, and virgins), followed by the twelve apostles. Only the right-hand part of the double page miniature of the choir of confessors, the choir of virgins, and the twelve apostles survive today. The most likely explanation of the loss of the earlier miniatures is that the Benedictional originally had a jewelled binding which was ripped off, taking the first few folios of the manuscript with it. According to the most recent reconstruction, six folios containing twelve full-page miniatures were lost in this way. The inspiration for this imposing cycle of double-page miniatures at the beginning of the Benedictional was apparently the Galba Psalter (London, British Library, Cotton MS. Galba A. xviii), a ninth-century Continental psalter which came to England at the beginning of the tenth century, when various miniatures were inserted in it. It has been assumed that the manuscript was at Winchester in the later tenth and eleventh centuries, but there in no firm corroboration for this.

The opening folios of the Benedictional with these representations of the heavenly choirs make a powerful visual and spiritual statement, which would have had a particular significance for the monks with whom Æthelwold lived and worked. The virtuous monk would have aspired to join the ranks of the choirs

[1] All translations of blessings from the Benedictional are taken from Robert Deshman, *The Benedictional of Æthelwold* (New Jersey and Chichester: Princeton University Press, 1995).

depicted at the beginning of the Benedictional. An eleventh-century life of Dunstan describes how he is welcomed into heaven by each of the celestial choirs, beginning with the angels and ending with the virgins, who acclaimed him and greeted him as one of their own.

The surviving part of the illustration of the Choir of Confessors shows seven saints. The three standing at the front are identified by inscriptions as (from left to right) Gregory the Great (*S[an]c[tu]s Gregorius praesul*), Benedict (*S[an]c[tu]s Benedictus abbas*) and Cuthbert (*S[an]c[tu]s Cuðbertus antistes*). St Benedict, as the founder of Benedictine monasticism and the author of the rule by which Æthelwold and his colleagues sought both to live themselves and to make the foundation of life in their cathedrals and re-established monasteries, is given the place of honour in the centre. Both Gregory the Great and Cuthbert were monks and intimately associated with the early flowering of monastic culture in England before the Viking invasions. Æthelwold regarded his own work in reviving monastic settlements as a continuation of the labours of these early pioneers. Each of the heavenly choirs are labelled 'choir of confessors', 'choir of virgins' and so on, in Latin inscriptions in letters of gold in the decorative arches above the figures. The inscription here reads 'CON/FES/SO/RU[M]'. Presumably the lost facing-page miniature had the corresponding inscription 'CHORUS'.

Folios 1v–2. The Choir of Virgins

The Virgins are shown in two groups, seven on the left and six on the right. Two of the figures in the right-hand group are identified by inscriptions on the books held by them. The inscription on the book held by the central figure is damaged, but probably identifies her as Saint Mary Magdalene. The figure to her left is identified as St Æthelthryth (often known as Etheldreda), the East Anglian queen who founded a monastery at Ely and was the most popular of the Anglo-Saxon women saints. Ely was refounded by Æthelwold and his special devotion to Æthelthryth is evident from the Benedictional. The artist has taken great care to give special prominence to the figures of Magdalene and Æthelthryth by, for example, giving them haloes rather than the crowns worn by the other figures.

Folios 2v–3 and 3v–4. The Apostles

The twelve apostles are shown in groups of three, spread over the two double-page spreads. The central figure on f. 3v is apparently St Paul; the central figure on f. 4 is identified as St Peter by the set of keys in his right hand.

Folios 4v–5. Dedicatory Poem

Immediately after the opening picture cycle of the choirs of the saints is the lengthy poem in Latin hexameters explaining the origins and purpose of the manuscript, which has been discussed above. The poem is written entirely in letters of gold and in a special display script of Roman rustic characters, which further distinguish the poem from the rest of the manuscript. However, the text is subtly tied into the visual programme of the manuscript. The references to the Day of Judgement at the beginning of the poem hark back to the eschatological components of the opening cycle of double-page miniatures, showing Christ and the choirs of saints.

Folios 5v–6. First Sunday in Advent: The Annunciation

The liturgical year begins at Advent. Advent is marked by a full-page miniature of the Annunciation, showing the Angel Gabriel telling the Virgin Mary that she is to bear a child who will be the Son of God. Mary is shown reading, with her right hand on the open book and holding a golden object in her left hand. The domed portico under which she sits is identified by Robert Deshman as a baldachin, a symbol of the heavens appropriate to a powerful ruler and indicating Mary's eminence as the Mother of Christ. Gabriel appears in the midst of a pink and white cloud, which also fills the baldachin. His right hand is raised in benediction and he bears in his left hand a sceptre. The opening words of the first blessing for Advent

Sunday ('May Almighty God, the advent of whose only begotten Son . . . ') are on the facing page in a decorative frame.

This miniature marks the beginning of the liturgical section of the manuscript, and the opportunity is taken to draw explicit parallels between the blessing bestowed on Mary through the Incarnation, declared at the Annunciation, and the episcopal blessing. Above the miniature are two Latin hexameters in gold capitals: 'The messenger from heaven stands here declaring to Mary: "Behold you, blessed, shall bear God and man at the same time".' Above the opening words of the blessing are another two hexameters: 'You, O Bishop, whoever you are who looks upon this heading, a blessing of this book of the advent of the Son of the loving father is at hand for you'.

The text of the first (Gregorian) blessing for Advent Sunday concludes on f. 6v. It reads as follows:

'May Omnipotent God, the advent of whose only begotten son you believe to have happened in the past and expect to occur in the future, sanctify you by the illumination of the same [Son's] advent, and enrich you with his blessing. Amen.

May he protect you from all adversity in the contest of the present life and show himself mild to you in judgement. Amen.

So that you, freed by him from all contagions of sins, might await the day of that terrible examination unafraid. Amen.'

The beginning of the alternative (Gallican) blessing for Advent on folio 7 perhaps helped inspire the cloud imagery in the miniature of the Annunciation: 'Open O Lord, the gates of heaven, and visit your people in peace, and send your spirits from above, and irrigate our earth, so that it may bring forth spiritual fruit for us.'

The two blessings for the second Sunday in Advent are found on folios 7v–9. The first blessing asks for help in expatiating all sin before the Second Coming, so that, when the time of Judgement should come, nothing should be found worthy of condemnation. It thus anticipates the imagery of the next miniature.

Folios 9v–10. Third Sunday in Advent: The Second Coming

Christ returns in divine and imperial majesty, bearing an imposing staff and with the words 'King of Kings and Lord of Lords' written in gold on his mantle. Christ is surrounded by symbols of his divinity: his halo, hair and beard are gold, and the *mandorla* in which his figure is framed is filled with the rays of divine light. Emerging from the cloud above Christ is a throng of Angels, appearing like an army following their leader. They carry the Books of Life together with the instruments of the passion: the cross, the nails, the sponge and the spear.

On folios 10v–15, the strict pattern of alternate Gregorian/Gallican blessings used for the first three Sundays in Advent breaks down as the fuller Gallican benedictional is used to provide blessings for particular celebrations in the days leading up to Christmas. The sequence is as follows:

folios 10–10v	3rd Sunday in Advent	Gregorian
folios 11–11v	Alternative blessing for the 3rd Sunday in Advent ('alia')	Gallican
folios 11v–12	Wednesday of Ember Week ('feria iv in ieiunio')	Gallican
folios 12–12v	Saturday of Ember Week ('feria vi')	Gallican
folio 13	Saturday of Ember Week ('sabbato in xii lectionibus')	Gallican
folios 13–13v	Christmas Eve	Gregorian
folios 13v–14	At Cockcrow ('in gallicantu')	Gallican
folios 14–14v	At first light on Christmas Day	Gallican

The blessing for Christmas Eve on folios 13–13v reads as follows:

'May almighty God, who by the incarnation of his only begotten Son put to flight the darkness of the world, and by his glorious nativity irradiated this most sacred night, put to flight the darkness of sins from us, and irradiate your hearts with the light of virtues. Amen.

And may he, who wished the great joy of his most sacred nativity to be announced to the shepherds by the angel, pour over you the most graceful dew of his blessing . . . Amen.

And may he, who by his incarnation joined earthly to heavenly inhabitants, fill you with the nectar of inner peace and good will, and make you colleagues of the heavenly troop. Amen.'

Folio 15v–16. Christmas Day: The Nativity

The page facing the miniature contains the opening of the first (Gregorian) blessing for Christmas, which begins 'May the all powerful Lord bless you' and describes Christ as 'the bread of the angels . . . the food of the faithful animals in the crib of the church'. The ox and ass are thus identified with the faithful flock of the Christian Church. They stand over the curious crib in the bottom left-hand corner, the elaborate structure of which is apparently meant to emphasise the analogy between the crib and the church. The figure standing over the bed on which Mary lies is apparently meant to be a midwife who, according to one legend, convinced a doubtful-looking Joseph of the miraculous nature of Mary's conception. The same story describes how the miracle was affirmed by the appearance of a bright cloud overshadowing Christ's birth, shown here as a pink cloud behind Joseph and the midwife.

After the Gallican blessing for Christmas (folios 16v–17) comes the first of the miniatures depicting the saints.

Folios 17v–18. Feast of St Stephen (26 December): The Martyrdom of Saint Stephen

The Acts of the Apostles describe how as Stephen, the first Christian martyr, was killed, he saw the heavens opening and Christ standing on the right hand of God. This miniature refers directly to this image, but shows Christ in a *mandorla* supported by two angels, without any depiction of the father. The second (Gallican) blessing for this day begins 'Open, we ask, Lord, your heavens and open our eyes; may your gifts descend to us from thence, and may our hearts look upon you from this side'. This idea is directly illustrated by the way in which the blue clouds beneath Christ's feet are shown to come between Stephen and his assailants.

Folios 19v–20. Feast of St John the Evangelist (27 December): St John

St John is shown seated at a lectern with a book and his traditional symbol of the eagle, which is blowing a horn, recalling how John trumpeted the word of the Lord. The first (Gregorian) blessing for this feast, which begins in the arch facing the miniature, reads:

'May almighty God deign to bless you through the intercession of the blessed apostle and evangelist John, through whom he wished to reveal the secrets of his word to the church. Amen.

May he grant to you that what he [John] inspired by the gift of the Holy Spirit, poured into your ears, you might be able to receive in your mind through the gift of that same spirit. Amen.

So that, having been instructed by his lesson of the divinity of our redeemer, and by loving what he has related, and by preaching what he has taught, and by carrying out what he has commanded, you might be found worthy to attain the rewards which the same Jesus Christ, our Lord, promised. Amen.'

A folio which would have contained a miniature of the massacre of the Holy Innocents, marking that feast on 28 December, has been lost. The decorative page containing the beginning of the first (Gregorian) blessing for the feast of the Holy Innocents survives, and is folio 21.

Folios 22v–23. Octave of the Nativity or Feast of the Circumcision (1 January): the Naming of Christ

Robert Deshman describes this miniature as 'one of the most enigmatic in the entire manuscript'. In the

top half of the picture, Mary lies in bed with the Christ child on her lap, surrounded again by the pink cloud which, as has been seen, the artist uses to depict divinity. In the bottom half of the picture, three seated men engage in animated conversation. These men have never been satisfactorily identified. They are perhaps relatives discussing what name to give the child. If that is the case, the figure in the middle might be Joseph.

Folios 24v–25. Feast of the Epiphany (6 January): Adoration of the Magi; the Baptism of Christ

The treatment of the sequence of blessings for Epiphany is unusual in that it is prefaced by two, rather than one, full-page miniatures. Both the miniatures are suffused with images relating to the kingship of Christ, and it may be that, for this reason, Epiphany was held to be an especially significant feast.

In the miniature of the Adoration of the Magi, the artist goes out of his way to emphasise the importance of kingship and the authority of Christ as 'King of Kings'. The Magi are shown wearing crowns; according to Robert Deshman, this is the first representation of them as crowned kings. Moreover, the first king is shown presenting Christ with a golden diadem, in a manner reminiscent of a subject prince acknowledging the superiority of an emperor. Christ is shown holding a book and bestowing his blessing on the Magi.

In the miniature of the Baptism of Christ, the ceremony becomes in effect a divine coronation. Flying angels bestow diadems and sceptres on Christ. A dove is shown bearing two vessels of holy oil, referring to the chrism used in a coronation, with the two vessels signifying Christ's dual role as king and priest. Opposite the dove is the hand of God (assisted by an angel), which hands down a wreath with which to crown Christ on the cross. The figure in the bottom left-hand corner is the river-god Jordan; his horns are probably intended to represent crab's claws

Alternative Gregorian and Gallican blessings are given for the feast of Epiphany itself. For the first five Sundays after Epiphany (folios 26v–29), the blessings are Gallican, but for the sixth Sunday after Epiphany (folios 29–30v), alternative Gregorian and Gallican blessings are provided. There then follow (folios 30v–34) blessings for the feasts of St Sebastian (20 January), St Agnes (21 January), St Vincent (22 January), the Conversion of St Paul (25 January) and a form of blessing for candles for use at the feast of the Purification. The blessing for the feast of St Vincent is the first blessing of apparently English composition to occur.

Folios 34v–35. Feast of the Purification of the Virgin (2 February): The Presentation in the Temple

Mary, accompanied by a handmaiden, presents Christ to the priest Simeon. The prophetess Anna stands next to Simeon. Towards the back can be seen the head of Joseph, and the turtle doves brought by him as an offering can be seen above Mary's head. The first (Gregorian) blessing for this feast reads as follows:

> 'May almighty God, who on this day wanted his only Begotten [Son] to be presented in the temple in the flesh that he had assumed, make you, supported by the gift of his blessing, to be adorned with good works. Amen.
>
> And may he, who wanted him [Christ] to be made a servant of the law in order to fulfil it, instruct your minds in the spiritual teachings of his law. Amen.
>
> So that you might be able to offer him gifts of chastity in place of turtle doves and that you may be enriched with the gifts of the Holy Spirit in place of young doves. Amen.'

The way in which different types of blessings have been integrated in the Benedictional is illustrated by the sequence between the feast of the Purification and Palm Sunday:

folios 35v–36	St Agatha (5 February)	Gallican
folios 36–36v	St Vedast (6 February)	Gallican
folios 36v–37	St Peter in Cathedra (22 February)	Gallican
folios 37–37v	St Gregory (12 March)	Gallican
folios 37v–38	Annunciation (25 March)	Gallican
folios 38–38v	St Ambrose (4 April)	Gallican

folios 38v–39	Septuagesima	Gregorian
folios 39–39v	Alternative blessing for Septuagesima	Gallican
folios 39v–40	Sexagesima	Gregorian
folio 40	Alternative blessing for Sexagesima	Gallican
folios 40–40v	Quinquagesima	Gregorian
folios 40v–41	Feria IV (Wednesday)	Gallican
folios 41–41v	Beginning of Lent	Gallican
folios 41v–42	Lent 1	Gregorian
folios 42–42v	Lent 2	Gallican
folios 42v–43	Alternative blessing for Lent 2	Gallican
folios 43–43v	Lent 3	Gregorian
folio 43v	Alternative blessing for Lent 3	Gregorian
folios 43v–44	Lent 4	Gallican
folios 44–45	Alternative blessing for Lent 4 or Lent 5	Gallican

Folios 45v–46. Palm Sunday: The Entry into Jerusalem

The services on Palm Sunday included an elaborate liturgical procession which re-enacted the events of Christ's entry into Jerusalem. The church congregation represented the citizens of Jerusalem, and bore both palms and flowers into the church, for presentation to the priest later in the mass. The flowers symbolised the flowers of Paradise. The miniature in the Benedictional draws on the imagery used in this liturgical re-enactment. The citizens behind Christ welcome him by waving palm leaves. Those at the top of the picture greet him, as did the congregation in the liturgical procession, with flowers. The miniature not only links the present (through the liturgical re-enactment) with the past, but also looks forward to a further triumphal entry of Christ at the time of the Second Coming, when the faithful should again be ready to greet him with flowers and palms. The blessing illustrated by the miniature includes (on folio 46v) the words:

'And may God grant you that, as you endeavoured to be presented to him with the branches of palms and other foliage, so you might be able to appear to him after death with the palm of victory and the fruit of good works. Amen'

This blessing is then followed by three further blessings for use in Passiontide (folios 46v–48v), two blessings for Maundy Thursday ('in caena domini'; folios 48v–49v) and two blessings for Holy Saturday (folios 49v–51).

Folios 51v–52. Easter: the Holy Women at the Tomb

The Angel sits at the entrance of the Tomb, and tells the women looking for Christ the good news. In the frame, the soldiers supposed to be guarding the tomb sleep. Again, the artist may well have had in mind imagery from a dramatic re-enactment which formed part of the liturgy. The *Regularis Concordia* describes how, during matins on Easter Day, the discovery of the empty tomb was the subject of a liturgical play, the focal point of which was a representation of the sepulchre in the church:

'While the third lesson is being read, four of the brethren shall vest, one of whom, wearing an alb as though for some different purpose, shall enter and go stealthily to the place of the 'sepulchre' and sit there quietly, holding a palm in his hand. Then, while the third respond is being sung, the other three brethren, vested in copes and holding thuribles in their hands, shall enter in their turn and go to the place of the 'sepulchre', step by step, as though searching for something. Now these things are done in imitation of the angel seated on the tomb and of the women coming with perfumes to anoint the body of Jesus. When, therefore, he that is seated shall see these three draw nigh, wandering about as it were and seeking something, he shall begin to sing softly and sweetly, 'Who Do You Seek?'. As soon as this has been sung right through, the three shall answer together, 'Jesus of Nazareth'. Then he that is seated shall say 'He is not here. He is arisen, just as he foretold. Go forth and speak out because he is arisen from the dead'. At this command the three shall turn to the choir saying 'Alleluia. The Lord is risen'. When this has been sung he that

is seated, as though calling them back, shall say the antiphon 'O Come and Behold the Place', and then, rising and lifting up the veil, he shall show them the place void of the Cross and with only the linen in which the Cross had been wrapped . . . '[1]

Gregorian and Gallican blessings are provided for use on Easter Day (folios 52–53v), then a series of Gregorian blessings for the Monday to Friday of Easter week (folios 53v–55v). The blessing for the Saturday after Easter (folios 55v–56) is Gallican.

Folios 56v–57. First Sunday after Easter: the Doubting of Thomas

The golden hair and beard of Christ, the use of a golden *mandorla* and the cross-staff borne by him link the imagery of this miniature to other illustrations in the Benedictional associated with the Second Coming. Among the Apostles, Peter may be identified by the large key which he is holding. The prominence of this attribute suggests a link to the imagery of the blessing which the miniature illustrates:

'May God whose only begotten Son on this day deigned to appear to his disciples with the doors closed, deign to enrich you within the gift of his blessing, and to open for you the doors of the celestial kingdom. Amen.

And may he, who removed the wound of doubt from their breasts by the touching of his body, grant that through the faith by which you have believed him to be resurrected, you may be freed of the stain of all transgressions. Amen.

And may you, who with Thomas believe him to be God and Lord and call him with suppliant voices, be able to be protected by him from all evils in this age and to stand with the ranks of the saints in the future. Amen.'

The sequence of blessings then proceeds as follows:

folios 57v–58	1st Sunday after the Octave of Easter	Gregorian
folios 58–58v	Alternative blessing for 1st Sunday after the Octave of Easter	Gregorian
folios 58v–59	2nd Sunday after the Octave of Easter	Gallican
folios 59–59v	Alternative blessing for 2nd Sunday after the Octave of Easter	Gallican
folios 59v–60	Alternative blessing for 2nd Sunday after the Octave of Easter	Gallican
folios 60–60v	Alternative blessing for 2nd Sunday after the Octave of Easter	Gallican
folios 60v–61	St Tiberius and St Valerian (14 April)	Gregorian
folios 61–61v	Invention of the Holy Cross (3 May)	Gregorian
folios 61v–62	Great Litany (25 April 'In Laetania maiore')	Gregorian
folios 62v–63	Alternative blessing for fast day ('Alia . . . de ieiunio')	Gallican
folios 63–63v	Eve of Ascension	Gregorian

Folios 64v–65. Feast of the Ascension: the Ascension

Christ ascends triumphantly into Heaven. One of his feet is still on the hill from which he rose up; the other strides up to the heavens. The hand of God the Father reaches down to him. Christ carries a cross staff which symbolises his triumph over death; the divinity of the resurrected Christ is again accentuated by the use of gold in his hair, beard and clothing. The *mandorla* surrounding Christ was originally filled by red rays of divine light, which have been obscured by rubbing. The divine cloud surrounding Christ harks back to the imagery of the miniatures of the Annunciation and the Nativity. Christ is surrounded by angels, but they refrain from assisting him in his ascent, adopting instead gestures of adoration. On the hill are gathered the Virgin Mary and the Apostles, to her right and left, who are shown in a gesture of prayer. The miniature of the Ascension is a good example of the way in which the artist blends together iconographical themes from a variety of sources, while adding his own distinctive touch. The active figure of Christ recalls Carolingian models, while the divine rays surrounding Christ are reminiscent of Byzantine sources. The cloud of divinity which the Ascension miniature shares with some of those of the birth and infancy of Christ is apparently an Anglo-Saxon innovation.

[1] Translation taken from *Regularis Concordia Anglicae Nationis Monachorum Sanctimonialiumque,* ed. and trans. Thomas Symons (London: Thomas Nelson, 1953)

Just one (Gregorian) blessing is given for the feast of the Ascension (folios 65–65v). It is followed by a Gallican blessing for the Sunday after Ascension (folio 66), and then a Gregorian blessing for the eve of Pentecost (folios 66v–67).

Folios 67v–68. Feast of Pentecost: Pentecost

The way in which the Benedictional blends Byzantine and Carolingian features while adding its own distinctive touches is again apparent in the miniature of Pentecost. Robert Deshman has shown how the arched arrangement of the figures of the Apostles receiving the gift from the Holy Spirit is similar to Byzantine manuscripts now in St Petersburg and Paris. On the other hand, the representation of the Holy Spirit as a dove, the agitated faces of the Apostles, and the prominence given to St Peter, the first figure on the right hand side of the bench, marked out by his gold tunic and attribute of a key, apparently represent Carolingian influence. An Anglo-Saxon innovation is perhaps the way in which the flames touch the Apostle's mouth, recalling the statement in the Acts of the Apostles that the Holy Spirit gave the Apostles the gift of speaking in divers tongues. The appearance of the Angels supporting the dove was also perhaps an innovation of the artist of the Benedictional. By portraying the Holy Spirit as a dove surrounded by angels, he was again referring back to the imagery he had used in depicting the Baptism of Christ. This theme may itself have been directly inspired by the imagery of the various Pentecostal blessings in the Benedictional itself. The blessing for the Saturday after Pentecost (folio 69v) reads as follows:

'May omnipotent God, who . . . granted you the remission of all sins in baptism by the Holy Spirit bless you. Amen.
And may he, who gave the same Holy Spirit in tongues of fire to his disciples, completely purify your hearts by its illumination . . . Amen.
So that, having been cleansed of all sins by his gift, you might be worthy to be protected from all adversities by its help, [and] to be effected its temple. [Amen]'

Folio 70. Octave of Pentecost or Trinity Sunday: Historiated initial O showing the Deity

The figure shown here in the act of making a blessing is at first sight that of Christ, but this feast was one on which the *Regularis Concordia* urged a special devotion to the Trinity. This figure may consequently have also been intended to convey the idea of the triune Godhead of God the Father, the Son and the Holy Ghost. This interpretation is further supported by the blessing of which this is the initial:

'May the omnipotent Trinity, the one and true God, the Father, the Son, and the Holy Spirit, allow you to desire him faithfully, to recognize him truly, and to love him sincerely. Amen.
May he so impress in your minds the equality and immutability of his essence, that he may never permit you to wander from his through any phantasms. Amen.
And may he allow you to continue so steadfastly in his faith and love, that afterward because of them he might lead you to his endless manifestation and appearance. Amen.'

The suggestion that this figure was also intended to convey the idea of the larger Godhead is supported by the rainbow throne on which the figure sits, which refers to the vision of God as expressed in the Book of Revelation: 'And behold there was a throne set in heaven, and upon the throne one sitting . . . And there was a rainbow round about the throne, in sight like unto an emerald'.

The sequence of blessings for the Sundays after Pentecost (folios 71–90) is notable for the fact that, while the first blessing for each Sunday is Gregorian, most of the alternative blessings are apparently of English origin. The only alternative blessings for this long series of Sundays which are Gallican are those for Pentecost 1–2, 5–7, 10, 17 and 23.

Folios 90v–91. Feast of St Æthelthryth (23 June): St Æthelthryth

The figure of St Æthelthryth is identified by a caption in gold letters within the frame containing her portrait: 'Imago s[an]cte Æðeldryðe abb[atisse] ac perpetue virgin[is]' ('The image of St Æthelthryth Abbess

and Perpetual Virgin'.) Æthelthryth (d. 679) was a daughter of King Ana of East Anglia. In about 652 she married the nobleman Tondberht. On his death in 655, she retired to Ely, but in 660 she was prevailed upon to marry King Ecgfrith of Northumberland who was fifteen years old. She remained celibate in both marriages. When Ecgfrith eventually insisted that she should have sex with him, she left him and became a nun. In 673, she founded Ely Abbey, which was reestablished by Æthelwold. She regarded the neck tumour which eventually killed her as a symptom of divine displeasure because she wore necklaces in her youth. The high esteem in which her feast was held by Æthelwold is indicated by the way in which it is given the most elaborate decorative scheme of all the blessings: both miniature and blessing are in ornate square frames which are heavily decorated with gold, and the initial of the blessing contains an historiated initial. The flower borne by Æthelthryth recalls Bede's description of the saint: 'Her worthiness bears many from the chaste shoot. Her worthiness bore virgin flowers.' The blessing for Æthelthryth is of English origin and may perhaps be by Æthelwold himself:

'May the one omnipotent and eternal God, the Father and the Son and the Holy Spirit, who made the will of the blessed Æthelthryth steadfast and so ablaze with the bounty of seven-fold grace that, summoned to the marriage beds of two husbands, she avoided them, remaining intact, and was taken as a chaste bride in perpetuity by the most just one, remove you from the burning desire of lust by protecting you, and kindle the fire of his own love. Amen.

And may he, who displayed her purity manifestly through her incorruptible body after death, and ineffably revealed her by signs of miracles, allow you to persevere faithfully in holy works, chaste to the end of your life. Amen.

So that remote from the desire for this vain world, [and] adorned with the lamps of all virtues, you may merit to have in Heaven the company of her who on account of her love, rejected the marriage bed of an earthly king and, having spurned the broad path of earthly desire, wished to adopt the narrow life of monasticism and on this day, obtaining her wish, deserved to enter the heavenly palace of the eternal king. Amen.'

Folios 92v–93. Feast of the Nativity of John the Baptist (24 June): Birth and Naming of John the Baptist

In the top half of the miniature, John's mother, Elizabeth, is shown reclining, with John himself in a crib. Elizabeth had insisted that her child should be called John, but the family's relatives and neighbours had wanted to call him Zacharias, after his father. The pose given by the artist to Elizabeth suggests that she is speaking, and is perhaps meant to connect the upper half of the picture with the bottom part of the miniature, where Zacharias, who had been struck dumb by his refusal to believe that his old and barren wife could be pregnant, indicates to those who had objected to the choice of name that his wife's wishes should be observed by writing in a book 'Johannes est nomen eius' (His name is John). Again, the divine presence at these events is expressed by the use of clouds; the celestial intervention in the naming of John is emphasised by the way in which the cloud envelopes the hand of the man interrogating Zacharias.

Folios 95v–96. Feast of St Peter and St Paul (29 June): Martyrdoms of Peter and Paul

In the top half of the picture, two executioners tie the feet of St Peter to the cross. Peter was crucified upside down because he did not consider himself worthy to be crucified in the same position as Christ. Below, an executioner, brandishing a sword in one hand and holding the sheath in the other, is about to behead St Paul, who is stretching out his hands towards the executioner. Again the use of gold (for the loin cloth wrapped around Peter and the tunic worn by Paul) emphasises the divinity of the two saints.

Folios 97v–98. Feast of Deposition of Saint Swithun (2 July): Saint Swithun

Saint Swithun was consecrated Bishop of Winchester in 852 or 853 and died sometime between 862 and 865. All that is known of his life are that he witnessed some charters of King Æthelwulf, made an episcopal profession to Canterbury, composed a Latin poem, and built a bridge in Winchester. On 15 July 971, the remains of Swithun were removed by Æthelwold from his grave outside the Old Minster to a magnificent

new shrine in the church, where miracles were soon reported. According to a (probably fictitious) twelfth-century anecdote, Swithun had been buried outside the church building at his own request 'where his body should be exposed both to the feet of passers-by and to the dripping of water from the eaves'. This is perhaps the origin of the legend that Swithun was annoyed that his body were moved by Æthelwold, so that if it rains on the anniversary of the translation of his remains, it will rain for the next forty days.

The miniature of St Swithun in the Benedictional reflects Æthelwold's vigorous promotion of his cult. The saint stands resplendent in golden episcopal vestments, cradling a golden book in his left arm and making the sign of blessing with his right hand. The mass commemorating Swithun's translation described him as an 'Olympic column of shining glory, illustrious with miraculous splendour', and the artist of the Benedictional here seeks to capture this sense of Swithun's supernatural radiance.

Folios 99v–100. Feast of Saint Benedict (11 July): Saint Benedict

This portrait of Benedict is related in its iconography to the lost frontispiece of St Æthelwold's translation of Benedict's monastic rule. Benedict (identified as 'S[an]c[tu]s Be/ne/dic/tus Abbas' by the caption within the frame) wears the crown of life. He holds a golden book, which is presumably his Rule, and proffers a golden crown. The picture very effectively conveys the idea that, by following Benedict's rule, one can attain the crown of eternal life. The blessing for this feast is of English composition:

'May the omnipotent Lord, who called to himself the holy blessed Abbot in the time of his youthful grace, and also chose him for ruling the monastic throng through the ardour of the Holy Spirit, sanctify you by the gift of his benediction. Amen

And may he illumine your heart so that you might be able to understand inwardly those things that are read in the house of God from the life of this father and by understanding you might be able to imitate him as often as possible. Amen.

So that instructed by his examples and not to mention strengthened by his prayers, you might pass unharmed through the moment of this life of labouring and might be worthy to be joined with him with the palm of glory in eternal peace. Amen.'

The blessing for the feast of St Benedict is followed by a blessing for the feast of St Laurence (10 August), also possibly of English composition (folios 101–101v).

Folios 102v–103. Feast of the Assumption of the Virgin (15 August): Death and Coronation of the Virgin

The miniature is based on incidents described in an apocryphal account of the Virgin's death which was well-known in late tenth-century England. It was said that, a few days before the Virgin died, the Apostles found themselves mysteriously and unexpectedly gathered together outside her house. Peter led them in prayer to seek a explanation of this miraculous reunion. This apostolic gathering is shown in the bottom of the miniature. Shortly before this event, the Virgin had told her neighbours that she would die in three days. The virgins attending Mary were said to have begun to weep. Mary, surrounded by her weeping attendants, is shown in the upper half of the miniature. One of the women is adjusting Mary's head-rest below. Above, an angel descends with a sceptre, while the hand of God descends with a golden crown.

The blessing for the feast of the Assumption is followed by a (Gallican) blessing for the feast of St Bartholomew (24 August; folio 104) and a Gregorian blessing with Gallican alternative for the feast of the Beheading of John the Baptist (29 August; folios 104v–105v).

Between the present folios 105v and 106, there is a gap in the text, where the beginning of the first blessings for the Nativity of the Virgin (8 September) should occur. It is likely that there was originally a miniature of the Nativity of the Virgin at this point, which has been removed. Likewise, opposite folio 108, a miniature of St Michael has been lost, and only the decorative arched page for the beginning of the (English) blessing for Michaelmas (25 September) remains. Between these two *lacunae* are blessings for the Exaltation of the Holy Cross (14 September; folios 106v–107), the feast of St Matthew (21 September; folios

107–107v) and the beginning of the blessing for the Saturday of the Ember Week in September ('Sabbato mense septimi').

The bulk of the blessings for particular saints' days in this section of the manuscript are of English composition. These comprise the alternative blessing for the feast of St Michael (folios 108v–109), the two blessings for the Feast of All Saints (1 November; folios 109v–110v), the blessings for the feasts of St Cecilia (22 November; folios 111v–112) and of St Clement (23 November; folios 112–112v), and the eve of St Andrew (29 November; folios 112v–113), the two blessings for St Andrew's day (30 November; folios 113–114), and the blessing for the feast of St Thomas the Apostle (21 December; folios 114–114v). The two blessings for the feast of St Martin (11 November; folios 110v–111v) are both Gallican.

The sequence of blessings for generic use on the festivals of those saints for which no particular blessing was provided are all of Gregorian origin. The sequence is as follows: One Apostle (folios 115–115v); One Martyr (folio 115v); Many Martyrs (folios 115v–116); One Bishop Confessor (folios 116–116v); Many Confessors (folio 116v); One Virgin (not a martyr) (folio 117); One Virgin Martyr (folio 117v–118); Many Virgins (folio 118).

Folio 118v. Dedication of a church: Bishop Blessing the Congregation

The illustrative scheme of the Benedictional concludes in a very appropriate fashion, with a picture of a bishop using a benedictional to pronounce a blessing on a congregation gathered together at the dedication of a new church building. The figure of the bishop has been assumed to be Æthelwold, but it is unlikely to be a direct portrait. Likewise, the surrounding buildings have been taken as depicting Winchester Cathedral as remodelled by Æthelwold, but again it is unlikely that this is a direct representation. At first sight, the picture looks half finished, with the only portions of the miniature which have been coloured being the figure of the Bishop, the benedictional held by him, the altar and the *ciborium,* the part of the church in which the altar stands, while the rest of the church building and congregation are given only as line drawings. However, it seems likely that this mixture of technique is intended to make a spiritual point: the building of the church is not important; far more important is the living Church of God's people. The bishop through his blessing provides the point of contact between the people of God's Church and the divine presence, as expressed in the colour of the preceding miniatures. The bishop's position as intermediary between God and man, the person whose blessing can help bind together the living Church, is reflected in the way his figure seems virtually merged with that of the altar. This theme is developed further by the (Gregorian) blessing:

'May the omnipotent God bless and keep you and this house [and] may he deign to illuminate you and this house by the presence of his gift, and deign to open the eyes of his kindness over it day and night. Amen.

And may he beneficently grant that all you who devoutly gather at the dedication of this basilica might be worthy, through the blessed intervention of N [the saint to whom the church is dedicated] and those other saints, whose relics here are devoutly venerated with love, to obtain the forgiveness of your sins. Amen.

Since with their intervention, you yourselves might be made the temple of the Holy Spirit, in which God, the Holy Trinity, might deign to dwell continuously, and alter the running out of the excursion of this life of labouring, you might merit to come successfully to eternal joy. Amen.'

DESCRIPTION OF THE MANUSCRIPT

BRITISH Library, Additional MS 49598. BENEDICTIONAL, written by the scribe Godeman for St Æthelwold, Bishop of Winchester; 963–984. *Latin.* The MS contains pontifical benedictions for use at mass on different days of the ecclesiastical year and a form for blessing candles on the feast of the Purification (f. 33), preceded by introductory verses relating to the execution of the MS. The local feasts provided for are those of St Vedast (f. 36), Ætheldreda (f. 91) and Swithun (f. 98). The blessings are as follows:

Advent 1	Gregorian form of blessing	f. 6
Alternative blessing ('alia') for Advent 1	Gallican form of blessing	f. 7
Advent 2	Gregorian	ff. 7–7v
Alternative blessing for Advent 2	Gallican	ff. 7v–9
Advent 3	Gregorian	ff. 10–10v
Alternative blessing for Advent 3	Gallican	ff. 10v–11
Advent 4	Gregorian	ff. 11–11v
Wednesday of Ember Week ('feria iv in ieiunio')	Gallican	ff. 11v–12
Saturday of Ember Week ('feria vi')	Gallican	ff. 12–12v
Saturday of Ember Week ('sabbato in xii lectionibus')	Gallican	ff. 12v–13
Christmas Eve	Gregorian	ff. 13–13v
At Cockcrow ('in gallicantu')	Gallican	ff. 13v–14
At First Light ('in primo mane')	Gallican	ff. 14–14v
Christmas Day	Gregorian	ff. 16–16v
Alternative blessing for Christmas Day	Gallican	ff. 16v–17
St Stephen	Gregorian	ff. 17–18v
Alternative blessing for St Stephen	Gallican	ff. 18v–19
St John the Evangelist	Gregorian	ff. 20–20v
[An alternative blessing for St John the Evangelist is now missing]	Gallican	
Holy Innocents	Gregorian	ff. 21–22
Alternative blessing for Holy Innocents	Gallican	ff. 21v–22
Octave of Christmas	Gregorian	ff. 23–24
Christmas 1	Gregorian	f. 24
Epiphany	Gregorian	ff. 25v–26
Alternative blessing for Epiphany	Gallican	ff. 26–26v
Epiphany 1	Gregorian	ff. 26v–27
Epiphany 2	Gregorian	ff. 27–27v
Epiphany 3	Gregorian	ff. 27v–28
Epiphany 4	Gregorian	ff. 28–28v
Epiphany 5	Gregorian	ff. 28v–29
Epiphany 6	Gregorian	ff. 29–29v
Alternative blessing for Epiphany 6	Gallican	ff. 29v–30v
St Sebastian	Gallican	ff. 30v–31
St Agnes	Gregorian	ff. 31–31v
St Vincent	English form of blessing	ff. 31v–32
Conversion of St Paul	Gregorian	ff. 32–32v
St Agnes	Gregorian	ff. 32v–33

Form of blessing of candles on feast of the Purification		ff. 33–34
Purification	Gregorian	ff. 35–35v
St Agatha	Gallican	ff. 35v–36
St Vedast	Gallican	ff. 36–36v
St Peter in Cathedra	Gallican	ff. 36v–37
St Gregory	Gallican	ff. 37–37v
Annunciation	Gallican	ff. 37v–38
St Ambrose	Gallican	ff. 38–38v
Septuagesima	Gregorian	ff. 38v–39
Alternative blessing for Septuagesima	Gallican	ff. 39–39v
Sexagesima	Gregorian	ff. 39v–40
Alternative blessing for Sexagesima	Gallican	f. 40
Quinquagesima	Gregorian	ff. 40–40v
Feria IV (Wednesday) of Quinquagesima	Gallican	ff. 40v–41
Beginning of Lent	Gallican	ff. 41–41v
Lent 1	Gregorian	ff. 41v–42
Lent 2	Gallican	ff. 42–42v
Alternative blessing for Lent 2	Gallican	ff. 42v–43
Lent 3	Gregorian	ff. 43–43v
Alternative blessing for Lent 3	Gregorian	f. 43v
Lent 4	Gallican	ff. 43v–44
Alternative blessing for Lent 4 or Lent 5	Gallican	ff. 44–45
Palm Sunday	Gregorian	f. 46
Alternative blessing for Passiontide ('in passione domini')	Gregorian	ff. 46v–47
Alternative blessing for Passiontide	Gallican	ff. 47–47v
Alternative blessing for Passiontide	Gallican	ff. 48–48v
Maundy Thursday ('in caena domini')	Gregorian	ff. 48v–49
Alternative blessing for Maundy Thursday	Gallican	ff. 49–49v
Holy Saturday	Gregorian	ff. 49v–50v
Alternative blessing for Holy Saturday	Gallican	ff. 50v–51
Easter Day	Gregorian	ff. 52–52v
Alternative blessing for Easter Day	Gallican	ff. 52v–53v
Monday of Easter Week (Feria II)	Gregorian	f. 53v
Tuesday of Easter Week (Feria III)	Gregorian	ff. 53v–54
Wednesday of Easter Week (Feria IV)	Gregorian	ff. 54–54v
Thursday of Easter Week (Feria V)	Gregorian	ff. 54v–55
Friday of Easter Week (Feria VI)	Gregorian	ff. 55–55v
Saturday after Easter	Gallican	ff. 55v–56
Octave of Easter	Gregorian	ff. 57–57v
Easter 1	Gregorian	ff. 57v–58
Alternative blessing for Easter 1	Gregorian	ff. 58–58v
Easter 2	Gallican	ff. 58v–59
Alternative blessing for Easter 2	Gallican	ff. 59–59v
Alternative blessing for Easter 2	Gallican	ff. 59v–60
Alternative blessing for Easter 2	Gallican	ff. 60–60v
SS Tiberius and Valerian	Gregorian	ff. 60v–61
Invention of Holy Cross	Gregorian	ff. 61–61v
Great Litany (25 April 'In Laetania maiore')	Gregorian	f. 61v–62
Alternative blessing for fast day	Gallican	ff. 62v–63
Eve of Ascension	Gregorian	ff. 63–63v
Ascension Day	Gregorian	ff. 65–65v

Sunday after Ascension	Gallican	f. 66
Eve of Pentecost	Gregorian	f. 66v–67
Pentecost	Gregorian	ff. 68–68v
Alternative blessing for Pentecost	Gallican	f. 69
Saturday after Pentecost	Gregorian	f. 69v
Octave of Pentecost	Gregorian	ff. 70–70v
Alternative blessing for octave of Pentecost	Gallican	ff. 70v–71
Pentecost 1	Gregorian	ff. 71–71v
Alternative blessing for Pentecost 1	Gallican	ff. 71v–72
Pentecost 2	Gregorian	ff. 72–72v
Alternative blessing for Pentecost 2	Gallican	f. 72v
Pentecost 3	English	ff. 72v–73v
Pentecost 4	Gregorian	f. 73v
Alternative blessing for Pentecost 4	English	ff. 73v–74
Pentecost 5	Gregorian	ff. 74–74v
Alternative blessing for Pentecost 5	Gallican	ff. 74v–75
Pentecost 6	Gregorian	f. 75
Alternative blessing for Pentecost 6	Gallican	ff. 75–76
Pentecost 7	Gregorian	f. 76
Alternative blessing for Pentecost 7	Gallican	ff. 76–77
Pentecost 8	Gregorian	ff. 77–77v
Alternative blessing for Pentecost 8	English	f. 77v–78
Pentecost 9	Gregorian	f. 78
Alternative blessing for Pentecost 9	English	ff. 78–78v
Pentecost 10	Gregorian	f. 79
Alternative blessing for Pentecost 10	Gallican	ff. 79–79v
Pentecost 11	Gregorian	ff. 79v–80
Alternative blessing for Pentecost 11	English	ff. 80–80v
Pentecost 12	Gregorian	f. 80v
Alternative blessing for Pentecost 12	English	ff. 80v–81
Pentecost 13	Gregorian	ff. 81–81v
Alternative blessing for Pentecost 13	English	ff. 81v–82
Pentecost 14	Gregorian	ff. 82–82v
Alternative blessing for Pentecost 14	English	ff. 82v–83
Pentecost 15	Gregorian	f. 83
Alternative blessing for Pentecost 15	English	ff. 83–83v
Pentecost 16	Gregorian	ff. 83v–84
Alternative blessing for Pentecost 16	English	ff. 84–84v
Pentecost 17	Gregorian	ff. 84v–85
Alternative blessing for Pentecost 17	Gallican	ff. 85–85v
Pentecost 18	Gregorian	f. 85v
Alternative blessing for Pentecost 18	English	ff. 86–86v
Pentecost 19	Gregorian	f. 86v
Alternative blessing for Pentecost 19	English	ff. 86v–87
Pentecost 20	Gregorian	ff. 87–87v
Alternative blessing for Pentecost 20	English	f. 87v
Pentecost 21	Gregorian	ff. 87v–88
Alternative blessing for Pentecost 21	English	ff. 88–88v
Pentecost 22	Gregorian	f. 89
Pentecost 23	Gregorian	ff. 89–89v
Alternative blessing for Pentecost 23	Gallican	ff. 89v–90
St Æthedreda	English	ff. 90–92

DESCRIPTION OF THE MANUSCRIPT

Nativity of St John the Baptist	Gregorian	ff. 93–93v
Alternative blessing for Nativity of St John the Baptist	Gallican	ff. 94–94v
SS Peter and Paul	Gregorian	ff. 96–96v
Alternative blessing for SS Peter and Paul	Gallican	ff. 96v–97
St Swithun	English	ff. 98–99
St Benedict	English	ff. 100–101
St Laurence	English (?)	ff. 101–101v
Assumption of the Blessed Virgin Mary	Gregorian	ff. 103–103v
St Bartholomew	Gallican	ff. 104–104v
Beheading of St John the Baptist	Gregorian	ff. 104v–105
Alternative blessing for Beheading of St John the Baptist	Gallican	ff. 105–105v
[Nativity of the Blessed Virgin Mary]	English (?)	Missing
Alternative blessing for the Nativity of the Blessed Virgin Mary	English (?)	f. 106
Exaltation of the Holy Cross	Gallican	ff. 106v–107
St Matthew	Gallican	ff. 107–107v
Saturday of Ember Week ('Sabbato mense septimi')	English	f. 107v
Michaelmas	English	ff. 108–108v
Alternative blessing for Michaelmas	English	ff. 108v–109
All Saints	English	ff. 109–110
Alternative blessing for All Saints	English (?)	ff. 110–110v
St Martin	Gallican	ff. 110v–111
Alternative blessing for St Martin	Gallican	ff. 111–111v
St Cecilia	English (?)	ff. 111v–112
St Clement	English	ff. 112–112v
Eve of St Andrew	English	ff. 112v–113
St Andrew	English	ff. 113–113v
Alternative blessing for St Andrew	English	ff. 113v–114
St Thomas	English	ff. 114–114v
One apostle	Gregorian	f. 115
One martyr	Gregorian	f. 115v
Many martyrs	Gregorian	ff. 115v–116
One bishop confessor	Gregorian	ff. 116–116v
Many confessors	Gregorian	ff. 116v–117
One virgin	Gregorian	f. 117
One virgin martyr	Gregorian	ff. 117v–118
Many virgins	Gregorian	ff. 118–118v
Dedication of a church	Gregorian	ff. 119–119v

Vellum; ff. ii+119+ 26*, 26*** (ff. ib and ii are paper laid on vellum). 292 × 225 mm. Cropped. Text space 210 × 140 mm. Gatherings irregular, *lacunae* between ff. 20 and 21, 105 and 106, 107 and 108. G. Warner and H. Wilson, *The Benedictional of St Æthelwold, Bishop of Winchester 963–984* (Oxford: The Roxburghe Club, 1910), described the manuscript before its rebinding in 1925, but did not provide a full collation. The precise collation is difficult to establish because of both the modern rebinding and the relative tightness of the existing binding. The position is further complicated by loss of leaves at the beginning of the volume and elsewhere. W. Schipper, 'Dry–Point Compilation Notes in the Benedictional of St Æthelwold', *British Library Journal* 20 (1994), pp. 19–20, argues that the missing pages at the beginning of the volume comprised a discreet gathering of 6 and 8. Collations are given in Schipper, *op. cit.*, pp. 29–32 and Robert Deshman, *The Benedictional of Æthelwold* (New Jersey and Chichester: Princeton University Press, 1995), pp. 257–8. They differ in some small details; as far as can be established, Deshman's collation is more accurate: i⁶ (1 and 6 conjoint half-sheets; Schipper gives 1 and 6 as bifolium), ii¹⁰ (1 and 2 singletons; Schipper

gives 3 and 10 as conjoint half sheets), iii^8 (5 missing), iv^{12} (9 and 10 singletons; 2 later medieval stubs after 3; Schipper gives 1 and 10 as singletons), v^8 (Schipper gives 1 and 8 as singletons) , vi^{10}, vii^{10}, viii4 (Schipper gives all four leaves as singletons), ix^{10}, x^8, xi^4, xii^6, xiii8, xiv^{10} (3, 4 and 7 missing), xv^9 (1 and 8 conjoint half sheets; 9 singleton). Written and illuminated probably at Winchester between 963 and 984; the circumstances of the execution of the MS by 'Godeman the scribe' at the express command of Æthelwold as Bishop of Winchester are given in the introductory verses on ff. 4v–5. St Æthelwold was consecrated Bishop of Winchester 29 November 963 and died 1 August 984. Wilson, *op. cit.*, pp. lvi–lvii thought the reference to miracles in the benediction for St Swithun implied that the benediction was composed after the saint's translation on 15 July 971. In any case, the prominence given to Ætheldreda in the MS suggests that it was not executed before the refoundation of Ely by Æthelwold in 970. Deshman, *op. cit.*, pp. 260–1, argues that the influence of the present MS is apparent in the figure style and ornament of drawings added circa 979 to the Leofric Missal, Oxford, Bodleian Library, MS. Bodley 579, giving a *terminus ante quem* for the execution of the Benedictional of circa 979. On the basis of iconographical evidence which he felt linked the Benedictional with the consecration of Edgar at Bath in 973, Deshman further proposes that the Benedictional was executed in that year: *ibid*. The entry in *Liber Vitae: Register and Martyrology of New Minster and Hyde Abbey, Winchester*, ed. W. de G. Birch (Hampshire Record Society, 1892), p. 24, apparently referring to Godeman suggests that he was a monk of the Old Minster, to which Æthelwold introduced monastic observance in 964. It is possible therefore that Godeman was one of the monks from Abingdon put by Æthelwold in place of the canons at the Old Minster, although there is no firm supporting evidence for this. Godeman is described in the Red Book of Thorney as having been a chaplain of Æthelwold: Warner and Wilson, *op. cit.*, p. xiii. Godeman was appointed by Æthelwold to be 'ruler and abbot' of the new foundation at Thorney, established circa 970: Michael Lapidge and Michael Winterbottom, *Wulfstan of Winchester: The Life of St Æthelwold* (Oxford: Clarendon Press, 1991), p. 41. It is not known when Godeman was appointed Abbot of Thorney. He does not witness charters as abbot until after 990. He continued to witness charters sporadically until 1013, and apparently died then or soon after: *ibid.*, p. 41.Godeman's hand also occurs in a fragment of a gospel book, London, College of Arms, MS. Arundel 22, ff. 84, 85: *The Golden Age of Anglo-Saxon Art*, ed. J. M. Backhouse, D. H. Turner and L. Webster (London: British Museum Publications, 1984), no. 38 and colour pl. vii. The first part of the 'Ramsey' Benedictional, Paris, Bibliothèque Nationale, MS. lat. 987, is also clearly from the same scriptorium and may be written by Godeman himself. T. A. M. Bishop, *English Caroline Minuscule* (Oxford: Clarendon Press, 1971), no. 12, suggests that the script is also closely related to those of Besançon, Bibliothèque Municipale 14 (Evangelia) and Paris, Bibliothèque Nationale, MS. lat. 272 (Evangelia). Written with normally 19 lines to a page. Dry-point ruling, made more than one sheet at a time, with double vertical guide lines, 12 mm. apart, the boundary lines of the text being reinforced by pencil lines apparently contemporary with the MS. Schipper, *op. cit.*, pp. 18–21, draws attention to double prickings and misrulings, suggesting that Godeman was reusing sheets of vellum that had been prepared earlier. He points out that these features, combined with the variety evident in the structure of the gatherings, 'creates the impression that the planning and assembly of the Benedictional was not a clear-cut process, and that the compiler improvised in a number of places'.

The main text is in a large Caroline minuscule. The first lines of the benedictions are written in rustic capitals, square capitals or uncials, depending on the importance of the occasion (see further below). Small uncial characters are used for the rubricated headings of the benedictions, except for the heading of the first benediction for the first Sunday after Pentecost (f. 70), which is in gold square capitals with a historiated intial. Small uncials are also used for text initials and Amens, which are also in red, except in the benediction for St Æthelreda, where the Amens are in gold. Schipper, *op. cit.*, pp. 21–28, drew attention to the appearance of dry-point notes on ff. 27, 27v, 58v, 60–63v, 104, 105, 106. They comprise incipits of blessings or notes of feast days, and were evidently intended to assist the scribe in ensuring that the blessings were copied in the correct order. However, some of the dry-point notes differ from the text as it stands in the

completed MS, suggesting that either the leaves were reused from an earlier, abandoned benedictional, or that Godeman was still in the process of ordering his text while he was preparing the leaves for writing.

The binding was described in 1910 (Warner and Wilson, *op. cit.*, p. x) as mellowed red morocco with a richly tooled back and a simple panel on the sides, dating from *circa* 1670, and attributed to Samuel Mearne, bookbinder to Charles II. The MS was rebound in 1925 by Sybil Pye, who stated in her notebook that it was 'Rebound in reddish-brown morocco, to match the sides of a former binding, probably by Samuel Mearne, *c.*1670, which were preserved. The back, etc., gold-tooled (see London, British Library, Additional MS. 73524F). This was apparently the only rebinding ever undertaken by Miss Pye and is the present binding of the MS.

The decoration of the MS consists of twenty-eight full-page miniatures, all, except the last, with either rectangular or arched decorative frames, and twenty pages with decorative frames, again either rectangular or arched. One of the pages with a decorative frame contains a historiated initial (f. 91) and there is also one historiated initial alone (f. 70). It is likely that the MS originally contained forty-three full-page miniatures and twenty-one text pages with decorative frames (see further below). The surviving full-page miniatures represent:

1. f. 1. The Choir of Confessors.
2,3. ff. 1v–2. The Choir of Virgins.
4–7. ff. 2v–4. The twelve Apostles, in groups of three.
8. f. 5v. First Sunday in Advent. The Annunciation.
9. f. 9v. Third Sunday in Advent. The Second Coming of Christ.
10. f. 15v. Christmas Day. The Nativity of Christ.
11. f. 17v. St Stephen. The Martyrdom of Stephen.
12. f. 19v. St John the Evangelist. John with his gospel and his symbol, an eagle.
13. f. 22v. Octave of Christmas. Above, the Virgin and Child; below, three men seated and talking.
14. f. 24v. Epiphany. The Adoration of the Magi.
15. f. 25. Epiphany. The Baptism of Christ.
16. f. 34v. The Purification. The Presentation of Christ in the Temple.
17. f. 45v. Palm Sunday. The Entry into Jerusalem.
18. f. 51v. Easter Sunday. The Women at the Sepulchre.
19. f. 56v. First Sunday after Easter. The Incredulity of Thomas.
20. f. 64v. Ascension Day. The Ascension of Christ.
21. f. 67v. Pentecost. The Descent of the Holy Spirit.
22. f. 90v. St Ætheldreda. Ætheldreda standing.
23. f. 92v. The Nativity of St John the Baptist. Above, St Elizabeth lying on a couch and the infant John in a crib; below, Zacharias writing John's name on a tablet.
24. f. 95v. St Peter and St Paul. The martyrdoms of Peter (above) and Paul (below).
25. f. 97v. St Swithun. Swithun, in mass vestments.
26. f. 99v. The Translation of St Benedict. Benedict seated, holding a book on his knee with his right hand and a crown in his left hand.
27. f. 102v. The Assumption. The Dormition of the Blessed Virgin.
28. f. 118v. Dedication of a Church. A bishop, pronouncing an episcopal blessing.

Since the miniatures of the Choir of Virgins (nos. 2, 3) and the Twelve Apostles (nos. 4–7) form diptychs on facing pages, it is likely that the Choir of Confessors (no. 1) faced another miniature showing seven crowned saints which is now lost. There were probably other miniatures at the beginning of the MS, showing further heavenly choirs. By analogy with the Æthelstan Psalter, London, British Library, Cotton MS. Galba A.xviii, it has been argued that six leaves containing twelve miniatures are missing at the beginning of the Benedictional and that their subjects were as follows: i. Christ in Majesty; ii, iii. Choir of Angels; x, xi. Choir of Martyrs; xii. First part of Choir of Confessors. The leaves removed between ff. 20 and 21, 105 and 106, 107 and 108 probably also contained miniatures. Folios 21 and 108 contain pages with decorative

frames which elsewhere in the MS always face full-page miniatures, while the leaves between ff. 105 and 106 apparently contained the opening of the benedictions for the feast of the Nativity of the Blesed Virgin, which is likely to have been marked by a full-page miniature. The subjects of these lost miniatures can be determined from the benedictions immediately following the gaps in the MS. The most probable reconstruction of these lost leaves is as follows: (1) Between ff. 20 and 21. Recto. Second benediction for the feast of the Nativity of St John the Evangelist, beg. 'Deus qui tuis apostolis'. Verso. Miniature of the Massacre of the Holy Innocents; (2) Between ff. 105 and 106. First leaf, recto. Blank. First leaf, verso. Miniature of the Nativity of the Blessed Virgin. Second leaf, recto. Opening of first benediction for the feast of the Nativity of the Blessed Virgin, beg. 'Omnipotens deus sua uos dignetur', with decorative frame. Second leaf, verso. Conclusion of previous benediction and opening of second benediction for the same feast, beg. 'Omnipotens deus qui per incarnatum uerbum'; (3) Betwen ff. 106 and 107. Recto. Conclusion of benediction 'Sabbato mense septimi'. Verso. Miniature of single figure of St Michael. The decoration and manner of writing are used in the MS to grade the benedictions according to the relative importance ascribed to different festivals. The categories are, in descending order of importance, as follows: (1) Full-page miniature, decorative frame for opening of benediction, historiated initial, opening of benediction in golden uncials and rustic capitals, with the golden uncials running on to the first two lines of the next page. Used only for Ætheldreda (ff. 90v–91v); (2) Full-page miniature, decorative frame for opening of benediction, opening words of benediction in golden square capitals, rustic capitals and uncials, varied occasionally by lines in red. Used for e.g. Swithun (f. 98) and Benedict (f. 100); (3) First line of benediction in gold capitals. Used for e.g. Agnes (f. 31), Agatha (f. 35v) and Cecilia (f. 111v); (4) First line of benediction in gold uncials. Used for e.g. Bartholomew (f. 104), Andrew (f.113) and Thomas (f. 114); (5) First line of benediction in plain black uncials, unless it is the second benediction for a particular festival, when it is in minuscule.

FURTHER READING

St Oswald of Worcester: Life and Influence , ed. Nicholas Brooks and Catherine Cubitt (London: Leicester University Press, 1996)

Robert Deshman, *The Benedictional of Æthelwold* (New Jersey and Chichester: Princeton University Press, 1995)

D. N. Dumville, *Liturgy and the Ecclesiastical History of Late Anglo-Saxon England* (Woodbridge: The Boydell Press, 1992)

—— *English Caroline Script and Monastic History* (Woodbridge, The Boydell Press, 1993)

Wulfstan of Winchester, *The Life of St Æthelwold*, ed. and trans. M. Lapidge and M. Winterbottom (Oxford: Oxford University Press, 1991)

Veronica Ortenberg, *The English Church and the Continent in the Tenth and Eleventh Centuries* (Oxford: Oxford University Press, 1992)

Tenth-Century studies. Essays in commemoration of the millennium of the Council of Winchester and the Regularis Concordia, ed. David Parsons (London: Phillimore, 1975)

St Dunstan: his Life, Times and Cult, ed. N. Ramsay, M. Sparks and T. R. Tatton Brown (Woodbridge: The Boydell Press, 1985)

Regularis Concordia Anglicae Nationis Monachorum Sanctimonialiumque, ed. and trans. Thomas Symons (London: Thomas Nelson, 1953)

The Golden Age of Anglo-Saxon Art 966–1066, ed. Janet Backhouse, D. H. Turner and Leslie Webster (London: British Museum Publications, 1984)

Bishop Æthelwold: His Career and Influence ed. Barbara Yorke (Woodbridge: The Boydell Press, 1988)

THE BENEDICTIONAL
OF
ST ÆTHELWOLD

CON FES
SOR RV

SCS GREGORIUS P...
SCS BENEDICTUS ABBAS
SCS CUD BERTUS...

CHO—RVS

VIRGI · NVM

3

Presentim biblu̅ iussit p̅scribere p̅sul
Quintoniae d̅n̅s que fecerat esse paronu̅
Magnus Apeluuoldus, uere gnarus b̅n̅ xp̅i
Agnos uelligeros a demonis arte maligna
Conseruare. d̅o fructu̅ quoq̅: reddere plenu̅
Iconomos clarus uenerabilis atq̅: benignus
Hic cupit. arbiter ut uenerit qui discutit orbis
Totius factu̅ quid quilibet egerit. atque
Mercede reddet qualem tunc forte merentur.
Aeterna̅ iustis uitam. iniustis quoq̅: poena̅s
Quenda̅ subiectu̅ monachu̅. ciacos quoq̅: multos
In hoc precepit fieri libro bene comptos
Completos quoq̅: agalmatib̅: uariis. decoratis
Multigenis miniis pulchris. necnon simul auro
Craxare hunc sibi prescriptus fecit boanarges
Dubco. ut soteris populu̅ in biblio potuisset
Su̅ficare. d̅o que preces effundere sacras
Pro grege comisso. nullu̅ quo p̅ada toullis
Agniculu̅ p̅abuu̅. ualeat sed dicere laetus

M EMET EGO ADSIGNO ECCE TIBI PUEROS QUOQ: QUOSTU
S ERVANDOS MIHI IAM DEDERAS NULLŪ LUPUS M DAX
E XILLIS RAPUIT TURCON TEMET FACIENTE.
S ET SIMUL ADSTAMUS VITA CUPIMUSQ: MANENTE
P ERCIPERE IN CAELIS QUE T UVI CŪ PRINCIPE SŪMO
C UIUS MEMBRA SUMUS CAPUT EST QUI VERE SALUS Q:
B APTIZATORŪ IN PATRIS ET NATI Q: FLAMINIS ALMI
N OMINE CLARISONO SI NON PER DEVIA VERGANT
S ED Q: EIDEM TENEANT FACTIS QUOQ: IUSSA SALUTIS
P ERFICIANT HERESIMQ: OMNEM DECORDE REPELLANT
P ECCAT Q: MALŪ SEMP SUPERARE STUDENTES
C ONIUNCTI DNO SINT IN CAELIS SINE FINE
H OC CUNCTIS CLEMENS TINCTIS BAPTISMATE SACRO
C ONCE AT XPC SOTER EST QUI REX BONUS ORBIS
A TQ: PATRI MAGNO IUSSIT QUI SCRIBERE LIBRŪ HUNC
A ETERNŪ REGNŪ CONCEDAT IN ARCE POLORUM
O MNES CERNENTES BIBLŪ HUNC SIMPROGITE HOC
P OST META CARNIS VALEAM CAELIS INHERERE
O B NIXE HOC ROGITAT SCRIPTOR SUPPLEX GODEMANN

Nuntius e celo hic erat predicando nove rei
Ecce dm paries homines: simul benedici...

SCA MARIA

QUISQ: CAP II ERNIS PREMIO EST BENEDICTIO P
LIBRO HUJUS NATI ADVEN... TIBI NAM P...
ALMI

O MPS

DS · CVIVS

UNIGENITI ADUENTUM

& praeteritum creditis & futuru̅
expectatis. eiusdemq; aduentus
uos illustratione sua sc̅ificet. &
sua benedictione locupletet. Am̅.

In presentis uitae stadio uos ab
omni aduersitate defendat. &
se uobis in iudicio placabilem
ostendat. Amen.

Quo a cunctis peccatorum conta
gnis liberati. illius tremendi ex
aminis diem expectetis interriti. Am̅.

Quod ipse prestare dignetur.
qui cum patre & sp̅u. co̅ uiuit
& gloriatur d̅s. per omnia
saecula saeculorum. Amen.

Benedictio d̅i patris. & filii. & sp̅s sc̅i.
& pax d̅ni sit semper uobiscum.
ET CUM SP̅U TUO.

ITEM ALIA

Aperi one laudis caeli. & uisita plebem tuam in pace · & mitte spm tuum de alto · & irriga terram nram · ut germinet nobis spu alem fructum · AMEN

Scifica plebem tuam dne · qui datus es nobis ex uirgine · & benedic hereditatem tuam in pace · AM

Praesta eis semper temporae salutis. quae ante tuum aduentum praedixit scs propheta iohannes. ut hic fideliter accipiant · & in futuro cum scis & electis tuis uitam & regnum consequantur aeternum · AMEN ·

Quod ipse praestat ·

DOMINICA SECUNDA

IN ADUENTU DNI

Cuius aduentus incarnationis pre teritus creditur. & iudicii uenturus expectatur. uos antequam ueniat expiet ab omni contagione delicti. AMEN

Prius in uobis deluat omne quod illa futura examinatione puniturus est. ut cum iustus aduenerit iudex. non in uobis inueniat quod condempnet AMEN

Quo ueniente non incurratis supplicium aeternum. sed remuneremini donariis sempiternis. AMEN

Quod ipse prastare dignetur.

ITEM ALIA BENED

EIUSDEM EBDOMAD

EXCITA DNE POTENTIA
tuam & ueni ad saluatio
nem populi tui. quem ad
quisisti sanguine tuo. ne
inimicus proditione seuus ille ex
ultet humani generis inimicus.
quem aduentus tui potentiae
dudum liberasti per gratiam.
Sit fortitudo dexterae tuae ad protec
tionem huius familiae tuae. pro
qua dignatus es hoc tempore car
nem induere uirginalem.
Ut dum infirmitatem nostram tua
clementia non ignorat. ita om
nem hanc ecclesiam tuam tuae
diuinitatis clypeo protege. ut
de saeui illius antiqui hostis tep
tatione nos liberes. & gentium

feritates ita mitiges · ut nihil eorū
iacula tuorum possint generare
dispendia · AMEN

Sed tu pastor bone qui te met ipsū
nri causa dedisti pro precio · ita
sanguinis tui defende commerciū ·
ut & hic te semper sentiant pre
tium · & in aeterna beatitudine
te remunerante mereantur acci
pere præmium · AMEN

Tu ergo omnipotens dne ihu xpe
benedictionum rore perfunde ·
ut & in presenti uita positi · de
omnibus inimicis te habeant
ereptorem · & hic & in aeternum
semper sentiant protectorē AM

Quod ipse præstare dignetur ·
cuius regnum & imperium ·
sine fine permanet in saecula

saeculorum · AMEN ·
Benedictio dī patris · & filii · &
spr̄s sc̄i · & pax dn̄i sit semper
uobiscum ·

OMPS

ds̄ · uos placido
uultu respiciat. et
in uos suę benedictionis

donum infundat. AMEN

Ut qui hos dies incarnationis uni
geniti sui fecit sollemnes. a cunc
tis presentis & futurae uitae
aduersitatibus uos reddat
indempnes. AMEN

Ut qui de aduentu redemptoris
nri secundum carnem deuota
mente laetamini. in secundo
cum in maiestate sua aduene
rit. praemiis uitae aeterne
ditemini. AMEN

Quod ipse praestare dignetur.

ITEM ALIA BEN

DNS IHC XPC
qui sacratissimo ad
uentu suo subuenire
dignatus est mundo. a
nimas uras corporaq: purificet

a delicto AMEN

Et uobis legis suae praecepta
uirtute sps sci adprehendere.
ut possitis aduentum eius inter
ritu praestolari: AMEN

Sicq; uos ab omni reatu Inmunes
efficiat. ut cum aduenit non
interrore discutiat. sed ingloria
remunerandos assumat: AM

Quod ipse praestare

BENEDICTIO
DOMINICA .IIII.

Ds qui uos et prioris
aduentus
gratia reparauit.
& insecundo daturum
se uobis regnum cum scis angelis
repromisit. aduentus sui uos
inlustratione scificet: AMEN

uinculan̄r dissoluat antequā
ueniat · ut liberati auinculis
peccatorum · interna tremendū
eius expectetis aduentum · Am̄

Et quem uenisse internis pro uīr
salute creditis · uenturumq; ad
iudicium sustineatis · eius aduentū
inpauidi mereamini contueri ·

Quod ipse prestare dignetur ·

FERIA QUARTA IN IEIUNIO ·

D̄S qui per tuum
angelum nuntiasti
xp̄m uenturum in sc̄lo ·
presta q̄s ut uenienti occurrere
populus mereatur cum gaudio Am̄

Idem uos benedicat ante natiuita
tem · qui suos benedixit ap̄los
post passionem · Am̄

Tribuatq: ipse uobis ueniam pec
catorum. qui pro salute huma
na fudit in cruce sanguinem
proprium. Amen.
Quod ipse
Deprecatui. Benedic
D̄S quies custos
animarum & cor
porum. hanc fami
liam dignare bracchii
tui defensione protegere. Am
Ut nullis antiqui hostis insidiis.
corpora nr̄x fraudesua patiatur
illudi. sed semper cum dn̄o nr̄o
ihūxp̄o filio tuo maneamus in
lesi. Amen.
Da huic familiae tuae fidei calorē.
continentiae rigorem. fraterni
tatis amorem. abstinentiae

uirtutem
quod ipse
Sabb in xii lection

Benedicat uos
omnipotens ds. & ad
omnem rectæ obseruan
tiae plenitudinem
auctor totius honestatis in
stituat. Amen.

Sit in uobis caritatis studium.
modestia morum. innocentis
uitae ingenium. fidei augmen
tum. concordiae fundamentū.
continentia uirtutum. benigni
tas affectuum. Amen

Et consequantur cum sc̄is premia.
& ante dm̄ appareant cum iusti
tiae palma. & cum illo perma
neant in gloria sempiterna.

quod ipse:
BENEDICTIO INUIGILIA
NATALIS DNI

OMPS DS
QUI INCAR
natione unigeni
ti sui mundi tene
bras effugauit. & eius gloriosa
natiuitate hanc sacratissimam
noctem inradiauit. effuget a
uobis tenebras uitiorum. & in
radiet corda uestra luce uirtutu. Amen

Quiq; eius sacratissimae natiuitatis
gaudium magnum pastoribus
ab angelo uoluit nuntiari. ipse
super uos benedictionis suae gra
tissimum imbrem infundat.

atq; ipso pastore uos ad aeterno
rum gaudiorum pascua aeterna
perducat. AMEN
Et qui per eius incarnationem ter
rena caelestibus sociauit. internę
pacis & boneuoluntatis uos nec
tare repleat. & caelestis militiae
consortes efficiat. AM. Quod

ITEM BENĎ IN GALLICANTU

Populum tuum
qs dne pio fauore prose
quere. pro quo dignatus es
in hac sacratissima nocte tuam
mundo praesentiam exhibere. AMŇ
A cunctis eum aduersitatibus
paterna pietate custodi. pro
quo mundo hoc in tempore
dignatus es ex uirgine nasci. AMŇ
Ut te redemptorem suum semper

intelligat · & tuam ueraciter
gratiam comprehendat· Amen
Quod ipse prestare dignetur.
cuius regnum & imperium.
sine fine permanet in scła scłor
Benedictio di patris

Item Benedictio
de natale dni
primo mane

Ds qui non solū
genus humanū
condere · sed etiam
renascente uoluisti
hominem de terris ad astra
transire · preces supplicum re
spice · qui te post longas tenebras
hodie natum lumen agnoscunt.
nobis in mundo dignatus es ex
hibere · Amen

Complectere hunc populum
in aecclesiae sinu · qui nobis
processisti mariae de thalamo ·
A M E N
Quod ipse praestare dignetur ·
cuius regnum & imperium ·
sine fine permanet in saecula
saeculorum · A M E N ·
Benedictio dī patris · & filii ·
& spī sci · & pax eius sit semper
uobiscum ·
ET cum spū tuo ·

15

Be
ne
DICATVS
OMPS DNS

uramque ad superna ex
cit & intentionem. qui hunc sacra
tissimum diem natiuitate filii sui
fecit esse sollemnem. AMEN
Et qui eum qui panis est angeloru.
in præsepi ecclesiae cibum fecit esse
fidelium animalium. ipse uos &
in presenti seculo degustare faciat
aeternorum dulcedinem gaudio
rum. & in futuro perducat ad so
cietatem aeternoru præmiorum.
AMEN
Quiq; eius infantiam uilibus uoluit
indui pannis. ipse uos caelestiu
uestimentorum induat orna
mentis. AMEN
Quod ipse præstare dignetur.
ITEM ALIA BENEDICTIO
DE NATALE DNI

D̄S qui genus humanū
uulneratum
in protoplasto nouo
recuperasti antidoto.
cum te astra non capiunt.
habitasti mulieris in utero. AMN
Respice populum tuum de excelso
habitaculo tuo. pro cuius redẽp
tione dignatus es nasci in mundo.
& nobis processisti mariae de
thalamo. AMEN
It pietate sedula intersit salus ho
minum. propter quos homo
factus es creator angelorum. &
de poenis infernalibus recupera
tor animarum. AMEN
Quod ipse prestare dignetur

IN NATAL SCI STEPHANI
PROTO MARTYRIS. BENO

DS
qui beatum stepha
num protomarty
rem coronauit.
Et confessione
fidei et agone
martyrii.
mentes ūrās
circumdet

in praesenti seculo corona iustitiae.
& in futuro perducat uos ad coro
nam gloriae. AMEN
Iuius obtentu tribuat uobis di
& proximi caritate semper exube
rare. qui hanc studuit inter lapi
dantium impetus obtinere. AM
Quo exemplis eius roborati. & in
tercessione muniti. ab eo quem
ille a dextris di uidit stantem.
mereamini benedici. AMEN.
Quod ipse praestare

ITEM ALIA BENEDICTIO DE
SCO STEPHANO.

Aperi quesumus dne
caelos tuos. aperi oculos
nros. Inde nobis tua dona
descendant. hinc te corda
nra respiciant. AMEN

Pateat nobis sedes tua in accipiendis beneficiis quae precamur. pateat tibi mens nostra in reddendis seruitiis quae iubemur. Amen

Habeat sanctum tuum stephanum pius iste populus patronum. quem etiam ille habuit impius ad uotum. Amen.

Quod ipse præstare dignetur cuius regnum & imperium. sine fine permanet in saecula saeculorum. Amen

OMPS
DS DIG
NETUR UOBIS P ERIN
TERCESSIONE BEATI
IOHANNIS APLI

&euangelistae benedicere. qui
per eum archana uerbi sui uoluit
ecclesiae reuelare. AMEN
Concedat uobis ut quod ille sps sci
munere afflatus uris auribus in
fudit. eiusdem sps dona capere
mente ualeatis. AMEN
Iuo eius documento de diuinitate
nri redemptoris edocti. & aman
do quod credidit. & praedicando
quod docuit. & exequendo quod
iussit. ad dona peruenire merea
mini. quae idem ihc xpc dns nr
repromisit. AMEN
Quod ipse praestare dignetur.
cuius regnum & imperium.
sine fine permanet in saecula
saeculorum.
ITEM DE SCO IOHANNE

O MPS DS

PRO CUIUS UNIGENITI
UENERANDA INFANTIA
INNOCENTŪ CATERUAS
HERODIS FUNESTE
PEREMIT SAEUITIA.

suae uobis benedictionis tribuat
dona gratissima · AMEN
Et quibus concessit unicum filium
eius dnm nrm · non loquendo
sed moriendo confiterentur ·
concedat uobis ut fidem ueram ·
quam lingua nnc fateatur. etiam
mores probi · & uita inculpabilis
fateatur · AMEN
Quiq: eos primitiuuum fructum scae
suae suscepit aecclae · cum fructu
bonorum operum uos faciat per
uenire ad gaudia aeternae patriae
AMEN ·
Quod ipse praestare dignetur ·

ITEM DE EIUSDEM ·
Concede qs one plebi
tuae innocentum gram ·
qui tibi consecrasti primi

tias martyrum abinnocentia
paruulorum · Amen ·

Seruetur hic populus purgatus
baptismate. qui tibi placitam fecisti
innocentiam incruore · Amen ·

Et illuc eorum interuentu grex acce
dat post lauacrum. ubi felices
paruuli perfusi rore sanguinis
gloriantur inperpetuum · Amen ·

Quod ipse prestare dignetur ·

OMPS
DS CVIVS
UNIGENITUS

hodierna die. qui legem soluere &
quam adimplere uenerat.
corporalem suscepit circumcisio
nem. spiritali circumcisione
mentes uras ab omnib; uitiorum
incentiuis expurget. & suam
in uos benedictionem infundat.
AMEN
Et qui legem per moysen dedit. ut
per mediatorem nostrum bene
dictionem daret. exuat uos
mortificatione uitiorum. & fa
ciat perseuerare in nouitate uir
tutum. AMEN
Quo sic in senarii numeri perfec
tione in hoc saeculo uiuatis. &
in septenario numero inter beato
rum spirituum agmina requiesca
tis. quatinus in octauo resurrecti

one renouati. iubelei remissione
ditati. adgaudia sinefine mansura
perueniatis. AMEN
quod ipse prestare dignetur.
DOMC. I. POST NATA
LEM DNI.
DS qui unigenitu
suum misit ut mun
dum saluaret. eiusde
salutis uos participes
efficiat. et in ea per
seuerabiles reddat. AMEN
Iram quae sup infideles manet
auobis amoueat. & ab ea uos in
perpetuu liberos efficiat. AM
Spm filii sui uobis attribuat. e
iusq; donis uos affatim exube
rare concedat AM quod.

BENED̄ · IN DIE THEOPH·

DS LUMEN UERŪ
qui unigeni
tum suum
hodierna die
stella duce gentib:
uoluit reuelari · sua
uos dignetur benedictione ditare Amen
Quo exemplo magorum mystica
dn̄o ihū xp̄o munera offerentes·
spreto antiquo hoste · spretisq:
contagiis uitiorum · ad aeternā
patriam redire ualeatis per uiam
uirtutum · AMEN ·
Detq: uobis uerum mentium inno
centiam · qui super unigenitū suū
spm̄ sc̄m demonstrari uoluit per
columbam · eaq: uirtute mentes
ur̄ae exerceantur ad intellegenda

diuinae legis archana. qua in
chana galilaeae limpha est in
uinum conuersa. AMEN:
Quod ipse praestare dignetur.

ITEM BENEDICTIO IN DIE THEOPH

DS qui praesentem diem
ita dignatus es eligere.
& ut eum eligeres tot
miraculis demonstrare.
in quo ad te adorandum stella no
ua magos perduxit. & iordanis
tuo baptismo scificari meruit. Hec
non & aquae pallor in chana gali
laeae uinum produxit. esto qs tue
familiae. ipse lux itineris. qui stella
indice clarificatus es rex saluus. AMEN.
Da plebi tuae redemptoris sui plenū
cognoscere fulgorem. ut per eius
incrementa ad perpetuam claritate

peruaniat ad ea...
Et qui dignatus es hodie ad iorda
nis fontem fons aquae uiuae
descendere. & tuo baptismate sci
ficare. tribue populis tuis perpetua
pace gaudere. & splendore gratiae
tuae semper accendae. AMEN
Quod ipse praestare.

Dom̃c. I. post Theoph.
Ds qui filii sui tem
poralem pueritiam
fecit esse mirabilem.
spū prudentiae corda ura
illustrare ac docere dignetur. Am̃
Qui q: cum parentib: temporaliter
subdi uoluit. ipse uos humilita
tis & pietatis muneribus misericor
diter informet. AMEN
Et qui cum sapientia. aetate. &

gratia proficere tribuit. spūa
lium uobis profectuum incre
menta propitius largiatur:
A M · Quod ipse

DOMC· II· POST THEO
PHANIAM·

DS qui sua mira
bili potestate aquā
uertit inuinum. uos
auctoritate subiectos
inbeatae uitae trans ferat no
uitatem· A M E N
Et qui nuptiis interesse uoluit.
ut earum sua praesentia com
probaret bonum. ipse uobis
castitatis & sobrietatis perpe
tuae conferat donum:
 A M E N
Ipse etiam uobis scārum intelli

gentiam scripturarum spūa
lem tribuat. qui aquas conuer
tendo inuinum hoc ipsum uo
luit designare: A M E N
Quod ipse præstare dignetur:

DOMC. IIII. POST
THEOPHAN
OMNPS DS uos
ab omnium pecca
torum maculis emun
det. qui leprosum supplicem
tactu proprio dignatus est
emundare. A M E N
Quiq; centurionis seruum non
aspernatus est uisitare. ipse
cordium uſrorum hospitium
dignetur misericorditer in

troire. AMEN.

Sicq: uos fidei suae plenitudine
informet. ut cum scis suis incae-
lorum regno accumbere con-
cedat. AMEN.
Quod ipse.

DOMIC. IIII. POST THE-
OPHANIAM.

Temptationum om-
nium auobis dns pericula
removeat. & perturbationum
procellas misertus excludat. AMEN.

Temptatoris fraudes atq: moli-
mina dissoluat. & uos aduer-
sus eum cautos atq: inuincibi-
les faciat. AMEN.

Continuae pacis uobis munera
tribuat. & uos importu tran-

quillitatis ac securitatis propi
tius custodiat.
AMEN
Quod ipse pręstare dignet̄
cuius regnum & imperiū.
sine perman& insc̄la sc̄lou͛.
AMEN
Dōmc̄. u. post theo
phaniam.
DS̄ qui bonum se
men in sua ecclesia
serere consueuit. in
uobis illud conseruare
atque multiplicare numquā
desistat AMEN
Zyzaniorum super seminatorē
auobis procul repellat. & sui
uerbi pabulo uos indesinenter
reficiat. AMEN

quo cum dies iudicii aduenerit
a reprobis separati. addexte
ram iudicis sistamini. & inbe
atissimo ipsius regno. collo
cemini.
A M E N
quod ipse prestare dignet
cuius regnum & imperiu
sine fine permanet in saecula
saeculorum. A M E N

DOMINICA · VI · POST THE
OPHANIAM ·
Ds qui mare suis
pedibus fecit esse
calcabile. uobis quic
quid est noxium ipse sub
sternat A M E N ·
Contineus inmundorum spiri

tuum motus compescat. &
uos insua pace confirmet.
 A M E N
Crucis suae nauim intermun
di fluctus gubernet. & militus
beatae perhennitatis perdu
cat A M E N
Quod ipse prestare dignetur.
cuius regnum & imperium
sine fine permanet insaecula
saeculorum.
 A M E N
Benedictio di patris. & filii. &
spś scī. & pax dñi sit semper
uobiscum:
 ITEM ALIA BENEDICT
 IN DOMC · UI · p̄ Tħ ·
Aspiciat et benedicat
uos dñs. ex omni parte

custodiat rex aeternus. & det
uobis angelum lucis. conser
uet in uobis gratiam quam p
fudit: AMEN
Mentem regat. uias dirigat.
cogitationes scās instruat. ac
tus probet. AMEN
Opera confirmet. uota perficiat
praeterita indulgendo emen
det. futura moderetur.
AMEN
Sit manus dñi auxiliatrix urī.
& brachium scm illius opitule
tur uobis.
Sit misericordia eius super uos.
& pietas illius subsequatur
uos. AMEN
Quod ipse praestare dignetur.
cuius regnum & imperium.

sine fine permanet in saecula
saeculorum
A M E N
Benedictio di patris . & filii .
& sps sci . & pax dni sit semp
uobiscum · A M E N

BENĎ IN NATL SCI SE
BASTIANI · MAR
D̄S qui triumphan
tibus prote martyr
ribus regiam caelestis
aulę potentiae dextera pan
dis · quiq: prote dimicantes sic
decoquis incorporeis erumnis ut
uelut aurū rutilans excipias in su
pernis · exaudi uota · praesentis po
puli tui · qui sco martyri tuo sebasti
ano in certamine uictoriā pstitisti · am

Sit plena huic laetitia ecclesiae pro eius triumpho. obtineat ipsius passio ueniam pro delicto. & effunde super eos dona sp̄ualiū uirtutum. ut nihil in eos inimicus aut uiolenter subripiat. aut fraude decipiat. AMEN

Et obtinente apud te beato martyre tuo sebastiano. cuius hodie festa celebramus. per bone conuersationis perseuerantiam. ad tuam mereamur pertingere gratiam. AM.

Quod ipse prestare.

Ben̄. IN NAT. SCĀE AGNETIS UIRGINIS. ET MART.

BENEDICAT UOBS
DN̄S. QUI BEATAE AGNE
UIRGINI CONCESSIT. & de

corem uirginitatis. & gloriam pas
sionis. AMEN
Et cuius opitulatione illa meruit
& sexus fragilitatem. & persequen
tium rabiem deuincere. uos pos
sitas & uestrorum corporum in lece
bras. & antiqui hostis machina
menta superare. AMEN
Quo sicut illa sexu fragili uirile prisa
est certamen adire. & post certam
de hostib; triumphare. Ita uos in
hac mortalitate uiuentes. ualeatis
& antiquum hostem deuincere. &
ad regna caelestia peruenire.
Quod ipse praestare.
BENĎ IN NŤL SČI UINCENTII.
Benedicat uobis dñs cęlorum
rector & conditor. & det uo
bis tranquillitate tempo

rum . salubritatem corporum .
salutemq; animarum : AMEN
Tribuatq; uobis frugalitatis gau
dium . interueniente beato uin
centio martyre suo . aeternitatis
premium . lumen clarissimum
sempiternum . AMEN :
Concedat uobis suae pietatis auxi
lium . ut cum cogitatione mens
uideat . lingua uoce proferat .
actio non offendat . AMEN
Quod ipse prestare SCI PAULI
BENO IN CONUERSIONE
Deus qui gratia sua be
atum paulum experse
cutore fecit apostolum .
ipse uobis conpunctionis piaeq;
conuersionis dignetur imperari
sp̄m . AMEN

Quiq; ei secretorum caelestium my
steria dignatus est reuelare. ipse
uobis scripturarum suarum ab
dita dignetur aperire. AMEN
Utq; uos perseuerantiam fidei con
stantiamq; in persecutionibus
inflexibilem dare dignatus e͞ eiusd͞e
interuentionib; uestram infirmita
tem. donis sp͞ualibus roborare
atq; munire dignetur. A͞m
Quod ipse p͞restare

BEN͞D IN NATIUITATE S͞C͞E
AGNETIS UIRGINIS·
Benedicat uobis d͞s
n͞ri oris alloquio
& cor u͞rm sinceri amo
ris copul& nexu perpe
tuo· AMEN·
Floreatis rerum presentium copiis.

iustitia adquisitis. gaudeatis per
henniter fructibus sinceris simae
caritatis

Tribuat uobis dns dona perhennia
interueniente beata agne uirgi
ne sua. & post tempora feliciter
dilatata. percipiatis gaudia sem
piterna.

Quod ipse prestare dignetur. cuius
regnum & imperium. sine fine
perman& in scla sclorum.

ORATIO SUPER CANDE
IN PURIFICATIONE S. MAR

Dne ihu xpe creator
caeli & terrae. rex regum
& dns dominantium. ex
audi nos indignos famulos tuos
clamantes. & orantes ad te. prece
camur te dne omps aeterne ds.

qui omnia ex nihilo creasti. &
iussu tuo opere apum hanc ceram
uel hunc liquorem uenire fecisti.
& qui hodierna die petitionem
iusti s{210}meonis implesti. te humi
liter deprecamur. ut has candelas
ad usus hominum & animarum
siue in terra. siue in aquis. per in
uocationem s{c}s{s}imi tui nominis
& per intercessionem sc̄ae mariae
genitricis tuae cuius hodie festa
colimus. per precesq; omnium
sc̄orum. benedicere & sc̄ificare
digneris. ut omnis haec plebs tua
illas honorificae In manibus
portantes cantando teq; laudan
do. tu exaudies uoces illius de caelo
sc̄o tuo. & de sede maiestatis tuae
propitiusq; sis omnib; clamantib;

ad te. quos redemisti pretio san
guinis tui · qui cum patre · & spu sco ·
uiuis & regnas ds̄ · per omnia sae
cula saeculorum · Amen ·

OMPS
DS QUI U
NIGENITU
suum

Hodierna die in assump
ta carne in templo uoluit prae
sentari. benedictionis suae uos
munere fultos bonis operibus
faciat exornari. AMEN

Quiq; eum ut legem adimpler&
ministrum uoluit effici legis.
mentes uras instruat legis suae
spiritalibus documentis. amen

Quo & pro turturib; castitatis
munera offerre ualeatis. & pro
pullis columbarum sps sci donis
exuberetis. amen.

Quod ipse praestare dignetur

BEN IN NT SCAE AGATHE uir

SFICA DNE EC
clesiam tuam qui
beatam agathen

uirginem & martyrem adquisisti
fide honorasti pudore. glorifi
casti certamine. AMEN

Repleatur hic populus illo spū. qui
martiri tuae affuit agathae. cum
eam ignis torreret. cum ungula
raderet. cum aculeus infigeret.
cum mamilla torqueret AMEN

Ut dum se sibi pro tuo amore abne
gat. tua collocetur in dextera.
cuius est electione uocata in glo
riam. AMEN

Quod ipse prestare dignetur

INNĒ SCI UEDASTI. CONF

DS FUNDATOR FIDEI.
& indultor sacerdotii.
congregatio plebis. sci
ficatio confessoris. qui be
atum uedastum ad hoc armasti

uirtute. ut tibi militaret infide. con-
cede huic familiae tuae pro se hunc
intercessorem. quem dedisti pontifi-
cem: AMEN.
Sit apud te nunc pro nobis assiduus
intercessor. qui contra hereticos. pro
te extitit tunc assertor: AMEN
Ut te retribuente populus crescat in
numero. pro quo sacerdos sudauit
infide: AMEN
Quod ipse praestare dignetur p̄r̄.
Ben̄. In cathedra s̄ci

D̄S qui beatum petrum
apostolum tuum ita reddi-
disti praecipuum. ut sor-
tiretur inter ipsos fidei principes
principatum. & accepta potestate
principis in scḋo. caeli fieret ianitor.
ut quos uult intromittat ciues in regno.

respice plebem tuam pietate solita.
qui sacro sco apto gressum firmasti
per lubrica. & culpas abluisti per
lamenta; AMEN.
Obtineat apud te ueniam procorri
gendis delictis. qui claudo fuit me
dela prodirigendis uestigiis; AM
Ut ipso intercedente & te remunerante.
illuc sibi greges commissos intro
ducat per ueniam. quo pastor
idemq; ianitor. tecum remunera
tus exultat ingloriam. AMEN
Quod ipse prestare. PAPAE

BENEDCO INN ESCI GREGORII
DS QUI BEATUM GREGO
rium presulem tuum
tanta familiaritate tibi
iunxisti. ut etiam cu adhuc
corpore habitaret in terris. iam tunc

corde totuf eff & incaelif · respice precef
praesentif familiae · quae se gaudet
tanti patroni sollempnia celebrare. AM

Valeat eius intercessione tibi illas peti
tiones effundere · quas eligis libenter
implere. AMEN.

Ut festiuitatem hanc uenisse internis
sentiant · quam uidere uotis incaelis
exoptant. AMEN

Quod ipse praestare dignetur.

Ben̄ In Adnunt. Sc̄e Marię

D S QVI CVM E
non capiant cęli
dignatus es in templo
uteri uirginalis includi ·
da aecclesiae tuae custodem angelū ·
qui filium mariae fide concipiente
praedixit. AMEN

Sctificetq; gregem tuum illa benedic
tio · quae sine semine humano ·
redemptorem nrm uirginis forma
uit in utero: AMEN·

Ut te protegente exultet ecclesia de
congregato populo · sicut maria
meruit gloriari de fructu pretioso
AMEN· Quod ipse prestare

IN N̄L SC̄I AMBROSII·

Dne d̄s omnium
gratiarum · respicere
dignare omnem hunc
populum tuum · qui in
honore tuo diuinis famulatur
officiis: AMEN·

Et quicquid sc̄o confessori tuo am
brosio hodierna die profuit ad be
atitudinem · prosit huic ecclesiae
ad exemplum: AMEN· q

Ut ipso intercedente. sit in eis fides
recta. imitabilis forma. casta so
brietas. hospitalis caritas. spualis
prudentia. alta sapientia. mens
humilis. uita sublimis: AMEN
Ut cum ante tremendum iudicii diem.
in conspectu tuo adstiterint. non
dampnandam. sed mitem ex ore tuo
audiant absolutionis sententiam.
AMEN Quod ipse prestare

BENĎ IN LXX.

OMPS DS. ITA STUDIUM
uri cursus dirigere dig
netur. ut brauium uos
aeternae uitae comprehen
dere faciat: AMEN
Et ita uos abstinentiae armis circum
det. ut nullis uitae huius oneribus
a peruentione retardet.

quiq; uos uineam suam uocare. uo
bisq; scōs operarios mittere digna
tus est. ipse uos sua gratia dignetur
excolere. ut denario uitae perhennis
remunerari non abnuat. Am
quod ipse praestare:

ITEM ALIA BENO

Respice dnē de caelo & uide. & uisi
ta uineam istam quam plan
tauit dextera tua. spūales
exhibeant fructus. & caelestes dili
gant actus. ut sine uitio in hoc sclo
transigant uitam. ut possint pro
mereri perpetuam: AMEN
Fragilem solida. contritum releua.
inualidum robora. ualidumque
confirma. pietate alleua. caritate
aedifica. castitate munda. sapientia
inlumina. misericordia serua. Am

Proficiant huic praecepta . fidei ui
gilantia . amoris tui perseuerantia
morum temperantia . misericor
diae prouidentia . actuum discipli
na . AMEN
Ut post concessam miserationis in
dulgentiam . non abicias eos a pro
missionis tuae munificentia . sed
perducas ad ueniam . quos tibi ad
optasti per gratiam : Am͞ Quod ipse

BENEDICTIO IN SEXAG̅

Det uobis d͞n͞s nosse
mẏsteria regni di . qui
iam dare dignatus est
auditum uerbi sui : Am͞
Sicq; manus uncas seminis sui copia
repleat . ut in uobis illud sibi placite
fructificare concedat : Amen
Et ita uos ab omni temptatione mu

niat . quatinus triceni . sexageni
atq; centeni fructus pro suae gnae
distributione . & munificentia mu
nerum faciat . AMEN
Quod ipse prestare . ITEM ALIA
Aspiciat in uos rector aeternus . atq;
conseruet in uobis gratiam qua
profudit . AMEN
Mentem regat . uias dirigat . cogitati
ones scas instruat . actus probet .
opera confirmet : preterita indul
geat . presentia emendet . futura
moderetur . AMEN .
Sit manus dni auxiliatrix uri . & bra
chium scm illius opituletur uobis .
AMEN : Quod ipse
BEN IN QUINQUAG
Os suauos benedicti
one confirmet . & inminentia

quadragesimali abstinentiae aptos
efficiat : AMEN
Quiq: caeco supplicanti perdiuturna
tis substantiam lumen restituit · ce
citatem uri cordis clementissimus
ac benignus illustret · AMEN
Quatinus uitiorum sordib: emundati
& caritatis ardore solidati · caelestem
hereditatem percipere ualeatis inlesi:
uod ipse prestare · AMEN

FER · IIII · IN QUINQUAG
Benedicone hunc popu
lum tuum fructib: bonis · &
operibus benedicat · AM
Faciat eos tali sobole germinare
ut in paradysi tui permaneant dig
nitate : AMEN ·
Planta eos in sinu matris ecclesiae ra
dicib: firmis · quo possint palatia

regni intrare caelestis: AMEN
Quod ipse prestare digneé:

BENĊO INITIO QUADRAĠ

BENEDICAT
uos dns ihs xpc..
qui se uobis uoluit
benedici. & qui hoc quad
ragenario curriculo cuius hodie
inchoatis exordium suo dedicauit
ieiunio. ut m suscipiat ieiunium.
omniq; uos repleat bono: AMEN
Det uobis integram fidem. & abstinen
tiam salubrem. ut nec caro aescis de
uicta luxuriet. nec mens afflicta de
generet: AMEN
Sed ita sit uobis scificatum in diuino
amore ieiunium. ut uitiis pariter
atq; corporib; abstinentiae frena

imponatis. &cou semp ab infestatio
nib: inimici maneatis inlaesi. &pax
iugiter quieta permaneat inhabita
culis uris· AMEN
Quod ipse prestare·

DOMC̄. I. IN QUADRAGS̄

Benedicat uobis omnps̄
ds̄. qui quadragenarium
numerum inmoysi & eliae
necnon & mediatoris nr̄i ie
iunio consecrauit AMEN
Concedatq; uobis ita transigere prae
sentis uitae dispensationem. ut accep
to apatre familias remunerationis
denario. peruenatis ad peccatorum
omnium remissione. & gloriosam
cum scīs omnib: resurrectionem: AM̄
Detq; uobis spūalium uirtutū uicto
tricia arma. quibus exemplo dn̄i

deuincere ualeatis antiqui hostis
sagacissima temptamenta: Amen
Quo non in solo pane sed in omni uerbo
quod de ore eius procedit spualem
sumentes alimoniam per ieuunioru
obseruationem . & caeterorum bono
rum operum exhibitionem percipe
re mereamini inmarcescibilem coro
nam : Amen : Quod ipse

DOMC II IN QUADRAGS

Benedictione populum
tuum & deuotum respice.
humilitatem uide . gemitus
suscipe . dolentes paterna pie
tate iube consolari : AMEN :

Prostratum alleua . dispersum con
grega . adunatum conserua . esurien
tem ciba . sitientem pota . omnesq;
simul caelestib; donis irriga: Amen

dele in eis omnem peccati maculam.
ut te gubernante ad gloriam perue
niant sempiternam. AMEN
humiliata tibi omnium capita. dex
tera tuae benedictione scīfica. ac be
nedicendo peccata relaxa. scīq; sp̄s
infunde carismata. AMEN
ut sine ulla offensione maiestatis tuae
praecepta adimpleant. & ad uitam
aeternā te auxiliante pueniant.
quod ipse. AMEN.

ITEM ALIA BENĎ.
Respice pastor bone super hunc
gregem. & tribue ut qui terré
nis abstinent cibis. sp̄ualib;
pascantur alimoniis. AMEN.
Et quem diuinis reficere tribuis sacra
mentis. ab omnib; propitiatus
peccatis. AMEN.

da eis sic in dieb: ieiuniorum suā componere uitam. ut non inueniantur uoluntates eorum a tua uoluntate dissimiles. sed sint semper in omnib: tuis præceptis obtemperantes AM

Et ita omnem hanc familiam tuam benedictione sc̄ifica. ut eorum ieiunia oculis tuae pietatis sint semper accepta. & ad desideratum sc̄æ resurrectionis tuæ diem. eos mundo corde & corpore pro tua pietate iubeas præsentari: AMEN:

quod ipse præstare:

DOMC · III · IN QUADR

DS̄ FONS INDULGENTIÆ suscipiat propitius litationem abstinentiæ uurę ā·
Impleat corda uitæ suarū delectatio onionib: hostiarum. & det

uobis posse suis parere preceptis.
Ut quod non potestis carnali ex infirmi
tate perficere. ipsius gratiae ubertate
mereamini adimplere. Amen. Quod.

ITEM ALIA BENEDIC
OMPS DS IEIUNII CETERA
rumq; uirtutum dedica
tor atq; amator. sua uos
benedictione sanctificet. AMEN
Accendat in uobis piae deuotionis af
fectum. & prebeat supplicantibus
suum benignus auditum. AMEN
Quatinus mentes uestre sinceris purga
tae ieiuniis. bonorum omnium ex
uberent incrementis. AMEN.
Quod ipse prestare.

DOMC. IIII. IN QUADR
DS QUI ES CUSTOS ANIMA
rum & corporum.

dignare hanc familiam tuam
brachio tuae defensionis protege
re · ut nullis inimicorum antiquo
rum hostium insidiis corpora nra
patiatur inludi · sed semper cum
dno nro ihu xpo filio tuo manea
mus inlesi : AMEN
Da huic familiae tuae fidei calorem.
abstinentiae uirtutem : AMEN
Et quicquid dicto facto cogitatio
nib: peccauerunt · pietas ac benig
nitas clementiae tuae misericordiae
resoluere. ac indulgere dignetur :
A M E N
Quod ipse praestare dignetur :
cuius regnum & imperium ·
sine fine permanet in scla saeculo
rum : AMEN
ITEM ALIA BENO

Dom cū· in quadrag·

Benedicat uos om͠ps
d͠s· & ad omnem rectam
obseruantiae plenitudi
nem totius honestatis
auctor instituat· AMEN·

Sit in uobis castitatis studium·
modestia morum· innocentus
uitae sinceritas· fidei integritas·
concordiae caritas· continentiae
uirtus· benignitatis effectus· am̄

Ad te oculos tendant· de te caelestia
sumant· ut te uotis expectent· se
claris actib: ornent· AMEN·

Et consequenter cum s͠cis premia
horum & multorum probitate
consecuta· referamus dignitas
praesentium bonorum· & aeterno
rum munerum largitori· am̄

quod ipse præstare dignetur

Bene
dicat
vos omps
ds cvi ie
IUNIORUM

maceratione & præsentium di-
erum obseruantia placere stu-
deas. AMEN
Concedatq; uobis ut sicut ea cum
ramis palmarum ceterarumue
frondium presentari studuistis.
ita cum palma uictoriae. & fruc-
tu bonorum operum ei post obi-
tum apparere ualeatis. Am.
Utq; unigenita filii eius passione
puro corde credatis. mente deuo-
ta uenerari studeas ad resurrecti-
onis eius festa. & unde remunera-
tionis præmia illius fulti mu-
nimine ueniatis. AMEN.
Quod ipse præstare dignetur.
cuius regnum & imperium.
ITEM ALIA BEND.
IN PASSIONE DNI.

Omnipotens ds.
qui unigeniti
sui passione tribuit
uobis humilitatis
exemplum · concedat
uobis per eandem humilitatem
percipere suae benedictionis in
effabile donum · AMEN
Ipsius resurrectionis percipiatis
consortia · cuius patientiae ue
nerammini documenta AMEN
quo ab eo sempiternae uitae mu
nus percipiatis · per cuius tempo
ralem mortem · aeternam uos e
uadere creditis · AMEN
Quod ipse

ITEM ALIA
Adesto omīps dś huic populo
tuo uerbis hodie mysticis in

formato. ut fiat illis illumina
tio mentis & reparatio cordis
inperpetuum : AMEN
Proficiat eis inlapsa benedictio
tua plenius adsalutem. quod
hac sacris mysteriis tuis suscepe
runt maures : AMEN
Sis illis protector &dñs inaeternū
sicut fuisti israheliticis tuis prae
monente morse insubsidium. &
aegyptiis inexterminium. utnon
praemerentur onenoso seruitio AMEN
Et ne ulterius grauentur mole
peccaminū. dignare circa eos
diuinum inperare praesidium
ut tibi famulari ualeant inae
ternum : AMEN
quod ipse praestare dignetur

ITEM ALIA

Ds qui pro salute
mundi uerbum
caro factus es & habi
tasti totus in nobis. qui
post caene mysterium traditori
perfido pium dedisti osculum.
dum pro uita hominum pius
uoluisti agnus occidi. respice uo
ta supplicum qui tua charisma
ta fideliter amplectuntur. AM

U aillis toto corde te colere. se ca
uere. te semper diligere. se mu
nire. AMEN

dsis protector aecclesiae. qui pro
nobis passus es iniurias synago
gae. AMEN

Ut te gubernante ad caelos patri
praesententur inlesi. pro quib:

ipse terras dignatus es illustra
re : AMeN. quod ipse

BeNd IN CaeNa dNI

BENEDICAT qos
os qui punic
passionem uetus pascha
in nouum uoluit conuer
ti : AMEN
Concedatq; uobis ut expurgato
ueteris fermenti contagio · noua
in nobis perseueret conspersio :
A M E N
Et qui ad celebrandam redempto
ris nri caenam mente deuota
conuenistis · aeternarum dapiu
uobiscum epulas reportetis AM
Ipsiusquoq; opitulante clementia

mundemini a sordib: peccato
rum. qui ad insinuandum humi
litatis exemplum pedes uoluit
lauare discipulorum. AMEN
Quod ipse præstare dignetur

ITEM ALIA

Benedic qs dne uniuer
sum hunc populum.
ad cæne conuiuium
euocatum AMEN
Protege eum tuae scuto defensio
nis. pro quo dignatus es obpro
bria sustinere passionis. AM
Defende eum a diri serpentis in
cursibus. atq; a cunctis absolue
sordib: qui in hac die pedes disci
pulorum humiliata maiesta
te propriis lauasti manib: AM
Benedicat uos omips ds qui in hac

die cum discipulis suis caenans.
panem in corpus suum. calicemq;
benedicens consecrauit in san
guinem : AMEN
Ipseq; uos faciat pura conscientia
mundaq; ab omni sorde pecca
ti. imminentem paschae sollem
nitatem cum exultatione placi
ta sibi celebrare. qui cum disci
pulis discumbens. desiderio ih
quid desideraui hoc pascha man
ducare uobiscum : AMEN
Ipse mentem uram scificet. uitā
amplificet. castimoniam decoret
atq; sensus uros in bonis operib;
semper aedificet. AMEN
Quod ipse prestare dignetur :

BENEDICTIO IN SABBATO

IN SCO PASCHAE.

DS QVI ECCLE
SIAE SVAE
intemerato utero
nouos populos producens. ea
uirginitate manente. noua
semper prole fecundet. fidei. spei.
& caritatis uos munere repleat.
& suae inuobis benedictionis do
na infundat. AMEN
Et qui hanc sacratissimam noctem
redemptoris nri resurrectione
uoluit inlustrare. mentes uras
peccatorum tenebris mundatas.
uirtutium copiis faciat corusca
re. AMEN
Quo eorum quimodo renati sunt

innocentiam imitari certetis. &
uascula mentium uirorum ex
emplo praesentium munerum
inlustretis · AMEN
ut cum bonorum operum lampa
dib: ad huius sponsi thalamum
cuius resurrectionem celebratis.
cum prudentibus uirginib: in
trare possitis · AMEN
quod ipse praestare dignetur ·
ITEM ALIA
QUI MORTEM NRAM.
DS ingressus inferni tar
tara inhac nocte de
uicisti uirtute diuina.
suscipe propitius familiae tuae
preces humillimas uoto sincere
mentis oblatas · AMEN ·
Et quos ueterib: maculis baptis

matis emundauit unda sacra
ta· per lauacrum tuae protecti
onis auxilio purgati· tales an
te te praesententur in iudiciu̅·
qualesnunc processerunt ex
baptismo· AMEN
Et qui te miserante reuocati sunt
in paradiso pereunte peccato·
non patiaris exules fieri renas
cente commisso· AMEN
Et qui te semel agnouit principe
uniuersitatis & dn̅m· numquā
inuasis sensib; in se triumfizan
tem sentiant inimicum· Am·
Quod ipse praestare dignetur·

Be
ne
B
DICATVS
OMPS DS

HODIERNA INTERUENIEN
te pascali sollempnitate · & ab
omni miseratus dignetur de
fendere prauitate · AMEN
Et qui ad aeternam uitam inuni
geniti sui resurrectione uos repa
rat · in ipsius aduentu inmorta
litatis uos gaudiis uestiat · AMEN
Et qui expletis ieiuniorum siue pas
sionis dominicae dieb: paschalis
festi gaudia caelebratis · ad ea
festa quae non sunt annua sed
continua ipso opitulante exul
tantib: animis ueniatis · AMEN
Quod ipse praestare dignetur ·
cuius regnum & imperium ·
sine fine permanet in saecula
saeculorum · AMEN
ITEM ALIA BENEDICTIO

DS QUI CAL EXTIS
inferni legibus cap
tiuitatem nrorum re
soluta hodie catena
rum compage dignatus
es ad libertatis premia reuocare.
inclina aures tuas ad uota populi
propitius· ut hinc ad te recupera
torem suum· sensus semper attol
lat intuitum AMEN

Te cognoscat· se corrigat· te prae
dicet· se commendet· te colat· se
muniat· te diligat· se praeparet
AMEN

Tu sis circumstantium sine inter
missione defensio· ipsi sint sine
hostis possessio tua inuasione·
AMEN

Ut ad beatae uitae gaudia festinan

tes· qui salutari fonte renati sunt.
peccati maculam non repetant.
originali excessu·

D̄S FERIA·II· BEN̄O
qui pro uobis suscepit
iniuriam crucis. Lae
titia uos innouet suę
resurrectionis· AM̄

Etqui pendendi secum in cruce la
troni amisit delictum. uos sal
uet a cunctis nexib; peccatoru̅· AM̄

Ut redemptionis urae mysterium.
& digne conuersatis in opere. &
locupletatis aeterna perfruamini
remuneratione· AMEN·
quod ipse prestare dignetur

D̄S FERIA·III· BEN̄O
qui uos Lauit
aquis sui lateris· & rede

mit effusione cruoris· ipse in
uobis confirmet gratiam adep
tae redemptionis· AMEN

Per quem renati estis exaqua &
spū sćō· ipse uos caelesti consociet
regno AMEN

Quiq; dedit uobis initia sćae fidei·
ipse conservet· & perfectionem
operis· & plenitudinem carita
tis· AMEN

Quod ipse praestare dignetur·
AMEN

FERIA ·IIII· BEN
DNS DS NOSTER·
Duos perducat ad ar
borem uitae· qui eru
it delacu miseriae· ip
se uobis aperiat ianuam para
dīsi· qui confregit portas in

ferni. A M E N
Ipse uos eruat aflagello. & inreg
num suum perducat confiden
tes. qui pati dignatus est pro
impiis innocens. A M E N
Quod ipse præstare dignetur.
cuius regnum & imperium
sine fine permanet in saecula
saeculorum. A M E N

FERIA·U· BENO
Omnipotentis dī
& dñi nr̃i benedica
onibus repleamini.
cuius estis sanguine pretioso
redempti. A M E N
Ipse uos indeficienti repleat gra
tia. cuius ineffabilis plasmauit
potentia. A M E N

et qui uobis in hoc mundo prae
stitit condicionem nascendi·
ipse in regno aeterno tribuat
mansionem · sine fine uiuen
di · AMEN
Quod ipse praestare dignetur·
cuius regnum & imperium·
sine fine permanet in saeculo
rum· AMEN

FERIA·VI· BEN̅O

Benedicat uos d̅s
de caelis omnipotens·
qui per crucem & sangui
nem passionis suae dig
natus est redimere internis· AM
p̅s uos renouet auctus tate pecca
ti· qui pro uobis dignatus est
crucifigi· uosq; ad caelestia sursa

tæ. qui pro uobis in sena pene
trauit. AMEN
Uitam suam dns uobis tribuat.
qui mortem uitam suscepit &
perdidit. AMEN
Quod ipse præstare

SABBATO · BENO
DS qui in terrorbis primordia
sub ducto fluctu pela
gi. ternas uario ger
mine fecundasti. conce
de pastor optime. gregem tuū
tuam resurrectionem celebran
tem. perhennib: pascuis intro
duc. AMEN
Ut te custode sic oues gubernen
tur & agni. ut nullus exeat lu
pum patiatur in prædam rap
torem. AMEN

Sed erepti de fauce lupi. panduntur
si mereantur floribus epulari.
AMEN
Quod ipse prestare dignetur.

D̄S
CVIVS VNI
GENITVS
hodierna die
discipulis suis

ianuis clausis dignatus est ap
parere · sua uos benedictionis
dono locupletare · & caelestis
uobis regni ianuas dignetur
aperire · AMEN ·
Et qui ab eorum pectorib; ad tac
tum sui corporis uulnus ampu
tauit dubietatis · concedat ut p
fidem qua eum resurrexisse
creditis omnium delictorum
maculis careatis · AMEN
Et qui cum cum thoma dm & dnm
creditis · & cernuis uocib; inuo
catis · ab eo & in hoc saeculo a
malis omnib; tueri · & in futuro
scorum coetib; adstare ualeatis
AMEN
Quod ipse prestare ·
DOMC · I · POST OCTA

BAS PASCHAE · BEN
EDICAT UOS OMPS
ds qui uos gratuita mi
seratione creauit.
& in resurrectione
unigeniti sui spem uobis resur
gendi concessit. AMEN
Resuscitet uos de uitiorum sepul
chris · qui eum resuscitauit a
mortuis. AMEN
Ut cum eo sine fine feliciter uiua
tis. quem resurrexisse a mortu
is feliciter creditis · AMEN
Quod ipse prestare dignetur.

ITEM ALIA BEN
DS qui per resurrec
tionem unigeniti sui
uobis contulit. & bonu

redemptionis & de eius adoptio
nis. suae uobis conferat praemia
benedictionis. AMEN

Et quo redimente percepistis do
num perpetuae libertatis. eo lar
giente consortes efficiamini ae
ternae hereditatis. AMEN

Et cui consurrexistis in baptismate
credendo. adiungi mereamini
in caelesti regione bene uiuendo
AMEN

Quod ipse praestare

DOMC. II. POST OCTA
BAS PASCHAE

Concede miseri
cors ds huic plebi
salutiferae paschae
sollempnia celebranti.
omnes ouium uellere in tua uo

luntate plantari. & sperare
quod tibi placuerit. & impetra
re sibi m[a]e quod oportet. AM

Te oculis intendat. corde teneat.
uoce concinat. & uotis requirat.
AMEN

Eui t& quod uetueris. eligat quod
iusseris. amplectatur quod dias.
impleat quo placaris. AM

Ut in ea mysticae pietatis tuae sa
cramento perfecto. prompte
suum diligat dnm. quae sangui
ne fuso. noua mercede intellegit
se redemptam. AMEN

Quod ipse prestare
ITEM ALIA

DS qui dignatione
misericordiae maie
state potenti. ut suc

curreres homini · terras caeli
tus uisitasti · praesta familiae
tuae ita hanc uitam transigere ·
ut in illam perpetuam reducente
possit intrare : AMEN
Tantum habeant feruorem catho
licae fidei · ut sci aduentus tui
sint expectatione securi · AM·
Vt quicumq; meruerunt purgari
unda baptismi · praesentari ua
leant tibi pio iudici canditati
AMEN Quod ipse :
ITEM ALIA
Deus qui de diuersis
floribus tuam semper
exornas ecclesiam ·
quam uelut boni odoris
flagrare fecisti · da plebi tuae
ad caelestem gloriam · & in mor

talitatis honorem renatae. dig
num regenerationis suae mentis
ornatum: AMEN
Et ut talesuitae cos finis inueniat.
quales fons regenerationis ami
sit. AMEN
Quod ipse praestare

ITEM ALIA.

OMPS SEMPITERNE DS.
qui resurgens amor
tuis passione cassata
potentiorem te tuis disci
pulis reddidisti. cumquibus e
tiam haec tempora post glorio
sam resurrectionem corporali
uisu tactuq; palpabili. per dies
quadraginta ut uerus ds & uerus
homo conuersatus es. exaudi
qs supplicem hunc populum.

ante conspectum tremendae
maiestatis tuae prostratum· AM
Benedic eum tua sacro scā benedic
tione· & paterna semper custodi
pietate· AMEN
Ut pro quib: dignatus es tam durum
sustinere passionem· numquam
hos permittas introire in suppli
cium gehennae· AMEN
Quod ipse praestare·

BEND IN NT SCORUM TI
BURTII ET UALERIANI

Benedicat uobis dn̄s
beatorum martirū suo
rum tiburtii & ualeriani
suffragiis & liberet ab ad
uersitatib: cunctas· AMEN
Commendet uos eorum intercessio
gloriosa· quorum in conspectu

eius est mors pretiosa: AMN
Ut sicut illi per diuersa genera tor
mentorum caelesti regni sunt
sortiti hereditatem. ita uos eorum
mereamini consortium per bo
norum operum exhibitionem: AMN
Quod ipse praestare dignetur
cuius regnum & imperium
sine fine permanet in saecula
saeculorū AMEN

BENEDCO INUENTI
ONE SCAE CRUCIS·

Benedicat uos om
nipotens ds. qui per
unigenita sui ihu xpi
dni nri passionem. &
crucis patibulum genus redemit
humanum· AMEN·
Concedatq: uobis· ut cum omnib:

scis quae sit eiusdem crucis longi
tudo. latitudo. sublimitas &
profundum. mente deuota co
prehendere possitis: AMEN
quatinus uosmetipsos abnegando.
crucemq; gestando. ita in pre
sentis uitae stadio redemptorē
nostrum possitis sequi. ut ei in
ter choros angelorum post obi
tum mereamini adsciscī: Amen
uod ipse praestare dignetur.
cuius regnum & imperium.
sine fine permanet in scla
saeculorum: AMEN
BENEDICTIO IN LAETA
NIA MAIORE.

o͞mps ōs. deuotio
nem urām dig
nanter intendat.

& suae uobis benedictionis dona concedat. AMEN

Indulgeat uobis mala omnia quae gessistis. & tribuat ueniam quam ab eo deposcitis. AMEN

Sicq; ieiunii uestri & precum uota suscipiat. ut a uobis aduersa omnia quae peccatorum retributione mereminini auertat. & donum in uos scs sps paraclitus infundat. AMEN

Quod ipse praestare dignetur. cuius regnum & imperium. sine fine permanet in saecula saeculorum. AMEN

Benedictio di patris. & filii. & sps sci.

AMEN

Item alia benedictio de ieiunio

Respice one super hanc familiam tuam subiectam tibi benedictionum tuarum dona poscentem. rege eam de superioribus tuis. & ubertatem fructuum largire eis. Amen

Libera eam a diebus malis. & a cogitatione bellorum. & da eis tempora tranquilla atq; pacifica. ut custode peruigili ac pastore aeterno. & præsenti tempore consistant securi. & ad aeterna gaudia perueniant liberi. Amen

Et qui quondam misericors misertus es turbę tecum triduo

permanenti · simili nunc dig
natione super hanc miserere
plebem · tibi ieiuniis & hymnis
innixius supplicantem ·
AMEN
quod ipse praestare dignetur ·
cuius regnum & imperium ·
sine fine permanet in saecula
sclorum · AMEN
Benedictio di patris · & filii · &
spi sci · & pax eius sit semper uo
biscum · AMEN

BENEDICTIO IN UIGILIA
ASCENSIONIS DNI ·
BENEDICTIONUM
SUARUM SUPER
UOS DNS IMBREM INFUN
DAT · & CLARITATIS SUAE

thesauros caelestes uobis ape-
riat. AMEN
Faciatq; uos dns uitae aeternae
participes. & regni caelestis co-
heredes. AMEN
Dignam inuobis habitationem
sps scs inueniat. & eius gloriosa
maiestas placide inuestris cor-
dibus requiescat. AMEN
Quod ipse praestare dignetur.
cuius regnum & imperium.
sine fine permanet insaecula
saeculorum.
AMEN.
Benedictio di patris. & filii. &
sps sci. & pax dni sit semper
uobiscum.

64

B^ENEDICAT

uos omnipots
ds. cuius

hodierna die unigenitus caelo-
rum alta penetrauit. & uobis
ubi ille est ascendendi aditum
patefecit. AMEN
Concedat propitius. ut sicut post
resurrectionem suam discipulis
manifestus. ita uobis in iudiciū
ueniens uideatur placatus.
AMEN
Etqui cum considere patri in sua
maiestate creditur. uobiscum
manere usq; in finem saeculi.
secundum suam promissionē
sentiatis. AMEN
Quod ipse praestare dignetur.
cuius regnum & imperium.
sine fine perman& in saecul-

DOMC POST ASCENS

qui tartara
fregisti resurgens.
aperuisti caelos ascen
dens. ut populi illuc per fidem
accederent. ubi te apostoli cum
gloria uiderunt intrare. respice
ascendens in caelum. propter
quod dignatus es descendere ad
infernum. AMEN
Sit eis quod te exaltasti protectio.
quibus fuit unicum quod te
humiliasti remedium. AM
Ut in die iudicii non sint sinistro
numero. qui te sedere ad patris
dexteram confitentur in regno.
AM Quod ipse.

BENCD IN UIGILIA PENTECOSTEN

Benedicat uos omnipotens dms. ob cuius paraclyti sps aduentū. mentes uras ieiunii obseruantia præparatas. & præsentem diem sollempnib; laudibus honoratis. AMEN

Instar modo renatorum infantiam talem innocentiam habeatis. ut templum scī spī ipso tribuente esse possitis. AM

Atq; idem sps scs. ita uos hodie sua habitatione dignos efficiat. ut cm se uestris mentib; uobiscum perpetim habiturus infundat. & peracto præsentis uitae curriculo. uos ad caelestia

regna perducat· Am·
quod ipse prœstare·

D̄S̄
QVI HODI
ERNA DIE
DISCIPV
LORUM

mentes sps paraclyti infusione
dignatus est inlustrare. faciat
uos sua benedictione repleri.
& eiusdem sps donis exuberare. AMEN

Ut ignis qui sup discipulos appa
ruit. peccatorum uestrorum
sordes expurget. & sui luminis
infusione corda uestra perlustret:
 A M E N

Quiq; dignatus est diuersitatem
linguarum in unius fidei con
fessione adunare. in eadem uos
faciat fide perseuerare. & per
hanc a spe ad speciem perue
nire. A M E N.

Quod ipse prestare dignetur.

ITEM ALIA

DS qui presentem
diem futurę remis
sionis munere figu
rasti · quoq gratia sci
spc inebriati apostoli mente
una locuti sunt ore diuerso · re
spice hanc ecclesiam · quam ex
gentib; congregari linguarum
uarietate signasti · AMEN

Da consolationem in ter processu
ris seculi · qui nobis hodie ae
qualem tibi ipsi consolatorem
spm misisti · AMEN

Utę propitiante sit ipse nunc ple
bis huius custodia · qui dedit
discipulis tunc doctrinam · AM

Quod ipse prestare ·

IN SABB PENTECOST

Benedicat uos om
nipotens ds · qui cunc
ta ex nihilo creauit·
& uobis in baptismate
per spm scm remissione
omnium peccatorum tribuit. AM

Quiq; eundem spm scm inigneis
linguis discipulis suis dedit; ipsius
illustratione corda uestra perlus
tret · atq; in suum amorem iugi
ter accendat : AMEN·

Quatinus eius dono a cunctis uiti
is emundati · ipsius opitulatio
ne ab omnib: aduersitatibus de
fensi · templum ipsius effici me
reamini : AMEN

Quod ipse prestare dignetur ·

DOMC · OCTABAS PENTECOST ·

O TRINITAS
VNVS ET VERVS
DS·PATER·ET·FILIVS·ET·SS·SCS

det uobiscum desiderare fideli
ter · agnoscere ueraciter · dilige
re sinceriter. AMEN

Aequalitatem atq; incommuta
bilitatem suae essentiae · ita
uestris mentib; infigat · ut ab eo
numquam uos quib;cumque
fantasiis ob errore permittat·
AMEN

Sicq; uos in sua fide & caritate per
seuerare concedat · ut per ea post
modum ad sui manifestatione
uisionemq; interminabilem in
troducat · AMEN

Quod ipse praestare·
ITEM ALIA. BEND

Dne ihu xpe qui disci
pulis tuis tuum spm tri
buisti · aecclae tuae catho

licae dona largire· AMEN·

Ut quicumq́: sunt ex aqua & spū
sco renati· semper sint eius protec
tione munita· AMEN·

Redundet in eis caritas diffusa per
spm scm· quae operiat acsupe
r& omnem multitudinem pecca
torum· AMEN·

Requiescat in istis propitius· qui
quondam requieuit in aposto
lis gloriosus· AMEN·

quod ipse· DOMOI·

POST PENTECOST·

Benedicat uobis DNS·
& custodiat uos·
Illuminet faciem super
uos· & misereatur uri· AM·
Conuertat uultum suū ad uos· &
det uobis pacem· AMEN·

quod ipse prestare

ITEM ALIA·

Respice dne de caelo. & uide & sita uineam istam quam plantauit dextera tua· AMEN

Spiritales exhibeant fructus· & caelestes diligant actus· AM

Et sine uitio in hoc saeculo transigant uitam suam· ut possint promereri perpetuam· AMEN

Fragilem solida· contritum releua· inualidum robora· ualidumq; confirma· AMEN

Pietate alleua· caritate aedifica castitate munda· sapientia illumina· miseratione conserua· AM

Proficiant huic praecepta· fidei uigilantia· amoris tui perseue

rentia . temperantia morum .
misericordiae prouidentia . ac
tuum disciplina : AMEN .
Et per concessam miserationis in
dulgentiam . non abicias eos
a promissionis tuae munificen
tia . sed perducas aduemam .
quos hic tibi adoptasti per gra
tiam . AMEN
Quod ipse .

DOMC . II . p̱ PENTEC
PROPITIETUR DNS
cunctis iniquitatibus
uestris . & sanet omnes lan
guores uros : AMEN
Redimat de interitu uitam uram .
& satiet in bonis desideriū urm :
Auferat a uobis cor lapideum .
& det uobis cor carneum . AM

quod ipse

Item alia

Agnoscat d(omi)n(u)s in uobis
proprium signum. & uobis
suae misericordiae con
ferat donum. Amen

Bella comprimat. famem auferat.
pacem tribuat. inimici insidias
longe repellat. Amen

Merentium gemitus uideat. uo
cem uiri doloris exaudiat. & la
crimas ab omni facie tergat. am(en)

Aeternam uobis direptionem in
dulgeat. & perfectam caritate(m)
concedat. Amen

quod ipse

Dom(ini)c(a) III p(ost) pentec(osten)

Benedicat uos om(ni)p(oten)s
d(eu)s. & caelesti dignatus au

xilio · gratiam uobis salutifere
benedictionis infundat · Amen ·
Auferat a uobis omnes maculas
delictorum · & mentes uras ad bo
nitatis intellegentiam benig
nus instituitor erudiat · Amen
Et præstet uobis uelle quae præ
cepit · inspiret quae diligit · &
tribuat quod oportet · atq; omi
uos bonorum spiritalium mu
nere · cum præsentium rerum
subministratione locupletet · Amen
Uitos in fide firmet · intemptati
one erigat · in conuersatione cu
stodiat · in uirtute multiplicet ·
in infirmitate releuet · in anxie
tate laetificet · Amen
In prosperitate præparet · in ae
quitate emendet · in tranquilli

tate sublimet· infundat gra
tiam· indulgeat offensam· in
gerat disciplinam· AMEN
Quod ipse·

DOMC·IIII·p̄ PENTēc·

MUNDET DN̄S CON SCI
entias urās ab omni ma
litia· & repleat sc̄ificati
one perpetua· AMEN
Vota urā clementer intendat· &
peccata omnia propitiatus in
dulgeat· AMEN
Quae pie optatis· miseratus attri
buat· & quae pauescatis· pius
propugnator procul repellat· Am
Quod ipse· AMEN
ITEM ALIA
BENEDICAT ET CUSTODIET
uos dn̄s· & sensus uros sui

luminis splendore perfundat· am
Illa uos tueatur potentia qua
condidit· illa uos pietate sčificet
qua redemit· AMEN·
Et ita custodiat de turbinib: huius
saeculi· ut in caelestib: coheredes
glorificatos dō offerat genito
ri· AMEN
Quod ipse·

DOM· U· P̄ PENTEC·
Omps ds· sua uos
clementia benedicat·
& sensum in uobis sapi
entiae salutaris infundat
AMEN·
Catholicae fidei uos documentis
enutriat· & in scīs operibus per
seuerabiles reddat· AMEN
Gressus uros ab errore conuertat·

& uiam uobis pacis & caritatis
ostendat· AMEN
Quod ipse

ITEM ALIA·
Benedicat uos ds pater
dñi nri ihū xp̄i · & respec
tu caelestis misericordiae
protegat uos sub umbra
uirtutis sue· AMEN
& uobis animarum conpunctio
nem· inmaculatam fidem· con
scientiae puritatem· AMEN
Sensus uestros dirigat· corda com
pungat· in prosperis adsistat·
in aduersis manum porrigat·
in laborib; solacium ferat· AM
Uirtutum suarum merita multi
plicet· recta consilia ad uocet·
religiosa uota confirmet· AM

Repleat corda uñra spiritalibus
donis. & abundare faciat in uo
bis semper perfectam gratiam
caritatis. AMEN
Quod ipse

DMC̄. UI. P̄ PENT.

Amoueat a uobis dns
totius maculas simulta
tis. & imbuat uos munc
ribus puritae dilectionis. ap̄s
Subiuget in uobis reluctatione
carnis & sanguinis. & opem con
ferat perpetuae castitatis. Am̄
Idq; uos in praesenti saeculo di
ligere faciat. quod a caelestis pa
radisi hereditate non diuidat
Am̄. Quod ipse
amen

ITEM ALIA BENEDICTIO

Dne ds omps. Hos
dommes in fonte baptis
matis sps tui munere
sacramentorum tuorum
plenitudini petimus preapara
ri. ut quorum animas mysterio
sci corporis tui satiasti. illos ad
uitam. cuius pignus est aeterna
perducere digneris. AMEN
Et qui spiritu tuum in primordio
super aquas in figura regene
rationis ririe per aquam salu
ti fieri ambulare fecisti. quiq:
per spiritum tuum tibi coaecter
num super filium in iordane.
gratiam spiritalem in columba
demostrusti. sup hanc plebem
qs dne fidelium nouiter reno
uatam. benignus respice. AM

ut quod audierint intellegant.
firmis cogitationib; credant.
& in firmitate perseuerent; Am
Quod ipse:

DOM VIII P PENTEC

INCLINET DNS AUREM SUAM
ad preces uestre humilitatis.
& det uobis suae benedictionis gram.
& premium sempiternae salu
tis A M E N.

Semp & ubiq; dnm propitium
habeatis. & in eius laudib; ex
ultetis. A M E N

Omnium peccatorum uestrorum
uincula soluat. & ad gloriam
sempiternam peruenire uos
faciat. A M E N

Quod ipse:

ITEM ALIA BENED

Dne ihu pastor
bone · qui animam
tuam pro ouib; posu
isti · sanguinis tui defende
commercium · AMEN
Gregem tuum propitius uisita
re dignare · esurientem pasce ·
sitientem pota · AMEN
Quod perierat requiro · quod er
rat conuerte · contritum con
liga · conforta inualidum · ua
lidumq; custodi · AMEN
Fac eos ante conspectum tuum
cum iustitia uiuere · & cum mi
sericordia sise custodieri in iu
dicare · AMEN
Tribue eis in fide credulitatem
in labore uirtutem · in affectu
deuotionem · in actu prosperi

tatem · in uictu abundantiá ·
in pace laetitiam · in conuersa
tione gratiam · in luctatione
uictoriam · AMEN
Ut in beneplacito conspectu tu
o crucmite gaudentes praesen
ti tempore · cum felicitate per
currant · & uenturum tempus
cum hilaritate suscipiant. amē
Quod ipse ·

Dom̄c uiii · p̄ pentēc
Sctificet uos dn̄i gra
tia · & ab omni malo
custodiat AMEN
Arceat a uobis omne quod ma
lum est · & sp̄s uros corporaq́:
purificet · AMEN
Alliget uos sibi uinculo carita
tis · & pax dn̄i habundet in

cordibus uris· AMEN
quod ipse

ITEM ALIA BEN
EDICAT ET SCIFICET
uos dns ex sion· qui fecit
caelum & terrā in sapien
tia· AMEN
Benedictione aeterna qua bene
dixit omnes scōs patres· & patri
archas uros· abraham· isaac· &
iacob· AMEN
Multiplicet in uobis gratiam spiri
talem· sicut multiplicauit sem
eorum tamquam stellas caeli·
& harenam quae est in litore
maris· AMEN·
Ille uos protegat atq; defendat·
omnib; dieb; uitae uirae· & per
ducat ad regnum gloriae·

uod ipse

DOMcA·IIII· POST PENTEC

Multiplicet in uobis
dns copiam suae bene
dictionis· & confirme
uos in spe regni caelestis. am
Accusuros corrigat· uitam emen
det· mores componat· & uos ad
caelestis patriae dñi hereditatem per
ducat·
Eaq: intentione repleri ualeatis·
qua ei inperpetuum placeatis. am
Quod ipse

ITom ALIA

Benedictionum suarū super
uos dns imbrem infundat
& orationes uras exaudi
at
Thesauros misericordiae suae uobis

aperiat . quod malum ardeat .
& uobis quod bonum tribuat . Am
Dignosq: uos faciat . quib: uirtutū
suarum secreta commisit . A malo
uos eruat . induci intemptatio
ne numquam permittat . Am
Dirigat uos dns in omni opere bono
& pax xpi quae praecellit omnē
sensum . corpora ura pariter cu
stodire dignetur & corda. Am
Illuminet oculos uros ad agniti
onem ueritatis suae . & in qua
cumq: die inuocaueritis eum .
propitius uobis adesse dignetur
Secundum diuitias gloriae suae.
omne quod ab eo poposceritis . im
petretis Amen
Quod ipse praestare .

Domc. x. p̄ pent̄c

Deus qui est uita mor
talium · salusq; pecca
torum · auferat a uobis
omnes maculas delictorū · *AMEN*

Induat uos decore uirtutum · sc̄i
ficet mentes · purificet uolunta
tes · & det uobis sc̄orum consortiū
angelorum · *AMEN*

Ut probabiles fide & opere immacu
lati · perueniatis ad aeternam gau
diorum caelestium hereditatē ·
Quod ipse · *ITEM ALIA*

Aspiciat & benedicat uos dn̄s
rector aeternus · & in omni
parte conseruet · *AMEN*

Det uobis dn̄s angelum summę lu
cis · ut conseruet in uobis gratiam

quam profudit. A M E N

Mentem regat. uias dirigat. actus
probet. cogitationes scās instruat.
A M E N

Opera confirmet. uota perficiat.
preterita indulgeat. presentia
emendet. futura moderetur. AM

Sit manus dni auxiliatrix & bra-
chium sci illius opituletur
uobis. A M E N

Sit misericordia eius super uos. &
pietas illius subsequatur uos. am

Quod ipse

DOM XI. P PENTEC

Deuotionem urām
dns dignanter intendat.
& suae uobis benedictionis
dona concedat. A M E N

Taliq; uos in pnti seculo subsi-

dio muniat. ut parted[r] si uos in
futuro habitatores efficiat. A[men]
Sicq; corda ura s[an]c[t]ificando benedi
cat. & benedicendo s[an]c[t]ific& . ut uo
bis cum immo in uobis cum iugi
ter habitare delect&. AMEN
Quod ipse.

ITEM ALIA BENE[DICTIO]

Benedic d[omi]ne hos populos tu
os. respectu tuo se suppli
ci oratione curuantes.
atq; hos omnes concordes.
quietos. pacificos. & sospites ser
ua. AMEN
Tribue eis ut sectentur non inten
tum sed uitam. non carne[m]. sed
sp[iritu]m. non temporalia. sed æter
na. AMEN.
Ut operibus suis non solum absoluta.

uerum etiam iustificati · digni
sint ueniam & gloriam promereri
Amen. Quod ipse ·

Dom̄c. XII. p̄ pentec̄

Ratia sua uos dn̄s
locupletet. & cælesti be
nedictione multiplicet. Am̄.
Ab omni uos aduersitate defendat
& pia semper miseratione custo
diat. Amen
Petitiones uestras placatus intendat.
& culparum omniū uobis ueniā
clementer attribuat. Amen
Quod ipse ·

Item alia

Sacratæ uitis benedictio se
cunda uos obtegat. excel
sæq; dexteræ uirtus altissi
ma benedicat. Amen

Botrus ille suspensus. ac processus
sanguinis uos haustu laetificæ.
spiritalisq; erbi dulcedine nu
triat acreformet: AMEN

Castitatis gloria cordauīt uelut
pampinea palmitis umbra arcu
tegat. lenibusq; flabris corpora
pudicitiae aura respergat: Am

Sīs decorata meus uineae orna
mento. atq; attolli cumfructu
iustitiae mercamini felices in
caelo: AMEN

Ut haurientes uinum nouum in
illo uernantis regno paradīsi
exulteas. ineo iugiter beati eius
corporis conformes effecti. Am

Quod ipse.

DOMC. XIII. P PENTECOST

Et uobis dns
munus suae benedica
onis · & repleat uos spu
ueritatis & pacis · Amen

Quatinus sic per uiam salutis deuo
ta mente curratis · ut subripienti
um delictorum laqueos salubri
ter euadatis · AMEN

Sicq; efficiamini in eius supplica
tione deuoti · & in mutua dilectio
ne sinceri · ut ad caeleste regnum
peruenire possiat securi · Amen

Quod ipse · ITEM ALIA

Benedicat uos ds mise
ricordia plenus · pietate
inmensus · maiestate glo
riosus · uirtute praecipuus Amen

Et uobis fidem sine scismate · dilec
tionem sine simulatione · integri

tatem sine crimine · continen
tiam sine lapsu · AMEN
Multiplicetur pax in cordib: ur̄is·
securitas in tempore · temperies
in aere · fructus in germine · AM
Vt dum uos pius miserator omnib:
bonis locupletat · in suam heredi
tatem propitius introducat · AM
Quod ipse ·

DOMC · XIIII · p̄ PENTEC̄
Benedictio uos dn̄i
comitetur ubiq: sibiq:
uos semp faciat adhe
rere · AMEN
Ipse uos sua benedictione saluifi
cet · qui dignatus est plasmare
potenter · AMEN
Atq: ita uos prœst& feliciter ueni
re · ut cælestis beatitudinis efficiat

coheredes. AMEN
Quod ipse ITEM ALIA.
Benedicat inuobis dns dns
imaginem quam plasma
uit. & det misericordiam
quam promisit. AMEN
Custodiat animas uras quas re
demit. seruando gratiā quam
profudit. AMEN
Ut & uos impleatis quae præcepit.
& ille custodiat. quod donauit AM
Ut qui nrm erga uos mandauit
sollicitudinem inpertire. semp
nos faciat deur̄ emendatione
gaudere. AMEN
Largam benedictionem super uos
dns effundat. & angelum suum
pacis castitatisq; inuobis consti
tuat. AMEN

Benedicat uos dñs ex sion· qui de
origine mortis· per uteri uirgi
nis suae natiuitatis gratia· nos
reparauit aduitam: Am̄

Dom̄c· xu· p̄ pentec̄

Concedat uobis om
nipotens dr̄· munus suae
benedictionis· qui uitæ
est conscius infirmitatis· Am̄

Et qui uobis tribuit supplicandi
effectum· tribuat consolationis
auxilium: AMEN

Ut ab eo & praesentis & futuræ
subsidium uitae capiatis· cuius
uos bonitate creatos esse credi
tis Am̄ uod ipse:

Item alia· Ben̄

Ds̄ qui aecclaetuae membra
de multis gentib: in uno

corpore dignatus es congregare.
precamur ut hic populus sit
tua maiestate munitus. cuius
est sanguine redemptus. Amen

Vt quem liberasti semel a crimine
tibi facias iugiter amore deuoto
seruire. Amen

Quod ipse:

DOMC. XUI. p̄ pent
Omnps ds peccato
rum uestrorum maculas
purget. & suauos bene
dictione illustret. Amen

Repleat uos spiritalium donis uir
tutum. & perseuerare faciat in
bonis propositum uestrum. Amen

Sicq; humilitatem uestram benign̄
acceptet. & suae uos pietatis re
muneratione locupletet. Amen

quod ipse · AMEN
ITEM ALIA

Respice dne super hanc famı
liam tuã quam de aegypti
erronib; eduxisti · & rep
missionem heredita
tis tuae uiuida riguitate plan
tasti · AMEN
Euangelicae falcis acie amputa
excea in puritae excrementa lux
uriae · ut ad instar uertex uitis
fructuum suorum generositate
florescat · AMEN
Nec acerui boni austeritate dege
neret · sed infecunditatis tuae dul
cedine glorietur · AMEN
Non exurenda sarmenta damni
abscisione uellantur · sed frugiferi
palmites tui in hac uita perma

neant· AMEN
Et inferalium sarmentorum la
sciuia expurgata proflua· legas
abea ubertate uindemiam· AM
Vt ferueat musto sp̅s̅ s̅c̅i̅ · castitate
purismentib; hauriendo deuo
te· AMEN
Nec luxuriosis crapulis uitietur
in crimine· sed in ebrietate cali
cis tuo poculo sobria permane
at in salutem· AMEN
Quod ipse·

Dom̅c̅ xiiii· p̅ pent
Omp̅s d̅s̅ caelesti
uos protectione cir
cumdet· & suae bene
dictionis dono locuple
tet· AMEN
Concedatq; uobis· ut qui in sola

spe gratiae caelestis innitimini.
caelesti etiam protectione mu-
niamini: AMEN
Quatinus & in praesenti saeculo
mortalis uitae solacia capiatis.
& sempiterna gaudia conpre-
hendere ualeatis: AMEN
Quod ipse

ITEM ALIA

Benedic hunc populum
d[omi]n[e] omnip[oten]s sempiterne d[eu]s. qui
es benedictionum largitor
& auditor: AMEN
Praesta ut haec hereditas nomini
tuo dicata. tua pascatur copia.
tua custodiatur gratia: tua in-
tellegat sacramenta. AMEN
Ut te iugiter credant. prompti
ad orent. honorifice te ameant.

gloriose diligant: AMEN

Tuaq; eos pietas per iustitiam regat. per misericordiam custodiat. per gratiam muneretur: AMEN

Quod ipse:

DOMC XVIII. p pen.

Omps ds. dexterę suae perpetuo uos circumdet auxilio. & benedictionum suarum repleat dono: AMEN

Ab omni uos pravitate defendat. & donis caelestib; exuberare concedat. AMEN

Quo corpore mundati ac mente. talem ei exhibeatis seruitutem. per quam suam consequi ualeatis propitiationem: AMEN

Quod ipse:

ITEM ALIA

Respice dne ad hanc familiã tuam quae tibi spontaneo famulatu. ora aperit. corda pandit. aures erigit. colla submittit. AMEN

Tribue eis in actib; crucem. in labiis laudem. in pectore fidem. in opere largitatem. AMEN

In uoluntate bonitatem. in conuersatione iustitiam. in morib; disciplinam. AMEN

Illa semper studeant agere te teste. quae possint excusare te iudice. AMEN

Ut in illo tremendo iudicii tui tempore. non inueniat in eis flama quod cruciet. quod iam in hoc saeculo conuersatio religiosa

mundauit · AMEN
Quodipse

DOMC · XVIIII · p pen̄

Urificet om̄ps ds
urorum cordium archana
qui benedictionis suae uobis tri
buit incrementa · AMEN
A bonnib: uitae praesentis pe
riculis exuamini · & uirtutū spiri
talium ornamentis induamini ·
AMEN · Quodipse
ITEM ALIA BEN̄D
Inclinata tibi capita maiestas
aeterna · dexterae tuae benedic
tione sc̄ifica · AMEN
Ut pleni redeant sc̄is muneribȝ qui
portas confessionis tuae deuota
mente ingressi sunt · AMEN
Scuto fidei & lorica euāgelii muni

antur. ne eos sagitta uolans p
diem. uenenosa rabies stimu
letur. AMEN
Et ne eos insomnis ruina moras
opprimat. de eorum pectorib;
crucis dexterae non recedat AM
Ut te pastore uigili protegente. ni
hil gregem redemptum noceat
os leonis AM Quod ipse.

DOM XX P PENT
Omps DS uniuersa
a uobis aduersa exclu
dat. & suae super uos be
nedictionis dona propitia
tus infundat. AMEN
Corda uestra efficiat sacris intenta
doctrinis. quo possint repleri
beneficiis sempiternis AMEN
Quatinus & exequenda intellegen

tes · & intellecta exequentes · &
inter aduersa mundi ueniami
ni indemnes · & beatorum spiri
tuum efficiamini coheredes. am
Quod ipse. ITEM ALIA. B
D̄S humani generis ipse
conditor qui redemp
tor · respice placatus
ad plebem quam sangui
ne unigeniti de morte placuit in
uitam transferri. AMEN ·
Et quam semel uoluisti purificare
per lauacrum · inmaculatam p
dua pie rex digneris in caelū am
Quod ipse.
DOM̄ · XXI · P PEN
Omps d̄s dies uros
in sua pace disponat.
& sua uobis benedictio

nis dona concedat: AMEN.
Ab omnib; uos perturbationib;
liberet. & mentes urās in suae
pacis tranquillitate consolidet. amē
Quatinus spei. fidei. & caritatis.
gemmis ornati. & præsentē uitā
transigatis illesi. & ad aeternam
perueniatis securi. AMEN
Quod ipse.

ITEM ALIA BEÑO
Domps indulge pecca
ta nr̄a. & non p̄mittas
nos plus tēptari. quā
nr̄a fragilitas potest sus
tinere. AMEN
Da nobis prudentiā. temperantiā.
fortitudinem. & iustitiā. ut hic
tibi bene placeamus. & ad uitā
aeternā puenire mereamur: Am̄.

et præsta omnib; peccantibus
ueniam. & per te uoca ad pæniten
tiam. ut uenturo die iudicari bi
mereamur præsentari idonei. Amen

Da nobis omps pacem & concordi
am. cu ommib; ciuib; fratribus
& sororib; nris: AMEN

Multiplica dne misericordiam tuam.
sup famulos tuos. & sup omnem
congregationem fratrum qui
in hac eccla sci ac beatissimi mar
tiris sui. ill aut confessoris con
stituit: AMEN

Peamus ut per eius intercessione
de lacu maligno nos liberare dig
neris. ut qui dignatus es in pere
grinatione comitari nos. hic
& ubiq; in scitate iubeas custo
dire. Amen quod ipse

Domc· XXII· p pen:

Benedictionis dni
gratia uos semper prote
gat. & ab omni malo de
fendat. Amen

Mundet uos ab omni crimine pec
catorum. & sibi met placere fa
ciat in aeternum. Amen

Ubiq; uobis dns placatus occurrat.
& suae benedictionis opem dig
manter attribuat. Amen

Quod ipse

Domc XXIII· p pen

Omips dns adape
riat cor uestrum in lege
sua. & humiliet animas
uras ad capienda mandata cae
lestia. Amen

Quicquid uobis pro salute anima

rum uīrtūtū ōs mortalitatis nr̄e e-
narrat . accepᵗᵘ uobis piecas diui-
na efficiat· A M E N

Ut diuinis sermonib: animati . cū
eis qui pro uobis inuigilant . ad
aeternam beatitudinem mere-
amini peruenire illesi · A M̄

quod ipse ·

ITEM ALIA

Benedic dn̄e omnem istam
familiam . qua e gr̄a iam
benedictionis tuae inue-
nire desiderat A M E N

Propriam manum eccaelesti emit-
te· & capita singulorum contin-
ge A M E N

Descendat super hos uiros habun-
dantia benedictionis tuae . sicut
descendit ros pluuiae sup faciem

ternæ: AMEN

Manus tuae sentiant tactum sps
sci percipiant gaudium. ut be
nedicti permaneant in aeternum·
AMEN.

Quod ipse praestare dignetur·
AMEN

BENEDICTIO IN NATALE SCÆ
AETHELDRYÞÆ PERPETUÆ VIRG

SCĒ ÆÞEL
OR YÞE
ABB AC PR
PETŸS VIRGIN

OMPS
UNU ET
PATER NUS
DEUS

PATER ET FILIUS ET SPS SCS.
qui beatae a· ðĊđopȳðę ānimū
septiformis gratiae ubertate
ita succensum solidauit· ut du
orum coniugum thalamis
assata immunis euaderet·
castamq; sibi piissimus sponsam
perpetim adoptaret· uos ab in
centiua libidinum concupiscentia
muniendo submoueat· & sui a
moris igne succendat· AmeN
Et qui eius integritatem per impu
tribile corpus post obitum mani
feste designauit· signisq; miracu
lorum ineffabiliter ostendit· uos
in suis operib; castos fideliter usq;
aduitae terminum perseuerare
concedat AMEN
Quatinus ab huius recidiui saeculi

cupiditate remota . uirtutum
omnium lampadib; adornata .
eius in caelis mercamini habere
consortium . quae terreni regis
caritatiue contempsit thalamū .
spretaq; lata terrenae cupidita
tis uia . artam monasticae con
uersationis eligere uoluit uitam .
ac hodierna die uoti compos . cae
lestem aeterni regis intrare pro
meruit aulam · AMEN
Quod ipse prestare dignetur ·

Benedicat vos omps ds

beati Iohannis
Baptistae in
tercessione.

cuius hodie natalicia celebratur.
concedatq; ut cuius sollempnia
colitis · patrocinia sentiatis : AMEN
Illius obtentu ab omnibus aduer
sis eripiamini · bonisq; omnib;
perfruamini · qui aduentum re
demptoris mundi · necdum na
tus cognouit · matris sterilitate
nascendo abstulit · patris linguā
natus absoluit AMEN
Quatenus ipsius agni quem ille
digito ostendit · cuius immolati
one estis redempti · ita uirtutum
lanis uestiri · & innocentiam ua
leatis imitari · ut ciui aeternae
patriae felicitate possitis adiun
gi · AMEN
Quod ipse praestare dignetur

ITEM ALIA BENEDICT IN DIE SCI IOHANNIS BAPTISTAE·

DS qui beatum Iohannem baptistam magnum nuntiasti per angelum · & maxime declarasti per uerbum · qui clausus in utero reddidit obsequium dno · matrem repleuit gaudio · patris linguam soluit a uinculo · cerne placato uultu confrequentantem hodie populum ad tanti praeconis occursum · AMEN

Ascendat uox illius ad aures altissimi · qui maternis usceribȝ ante mundi dnm nouit confiteri quā nasci · AMEN

Et eo intercedente purgetur plebs

acrimine · cuius auctorem laua
cri sacra dextera tinxit infonte ·
A M E N ·
quod ipse praestare dignetur ·
cuius regnum & imperium ·
sine fine permanet insaecula
saeculorum : A M E N

95

BE
NEDICAT UOS DS
QUI NOS BEATI
PETRI SALUBERRI
MA CONFESSIONE

in ecclesiasticae fidei fundauit
soliditate. AMEN
Et quos beati pauli sctissima in
struxit praedicatione. sua tue
atur grauissima defensione: Am
Quatenus petrus claue. paulus
sermone. utriq; intercessione.
ad illam uos certent patriam in
troducere. ad quam illi alter cru
ce. alter gladio hodierna die per
uenere. Am. Quod ipse.

Item alia Beno
Ds qui in membris
ecclesiae uelut
geminatum lumen
quo amouentur
tenebrae fecisti petri la
crimas pauli litteras coruscare

hanc plebem placatus inspice.
qui caelos fecisti aperire petro
in claue. paulo in dogmate· Amen
Ut praeuiantib; duabus. illuc
grex possit accedere. quo per ue
nerunt pariter. tam ille pastor
suspendio. quam iste doctor
interemptus gladio· AMEN
Quod ipse praestare·

A M E N ·

D̄S
QVI PRAE
SENTIS
DIEI FESTI
UITATEM
IN BEATI

ANTISTITIS SUUITHUNI.

celebritate uenerabilem sanx
isti. tribue nobis tanti patro
nis interuentu practicae ui
tae subsidium. ac aeternae
theoricae lucrum.

AMEN

Quiq: illum nouissimis ferme
mundi temporibus multi
plici acpene ineffabili miracu
lorum copia utfidei facula
idenadem succender& sassimū
manifestare uoluit. uos uirtu
tum omnium fecunditate
floridos fidei spei caritatisq:
rore perfusos. insćo proposito
cum bonis operib: perseuerare
concedat. AMEN

Quo pii suffragatoris doctrina

irradiati · & multiplici suffra
gio corroborati · illi in caelef
ti regione mereamini adiun
gi · qui hodierna die tripudi
ans caeli secreta penetrauit·
 A M E N
Quod ipse praestare·

OMPS
DNS

uosque benedictio
nis dono scificet.
qui beatum

BENEDICTUM
abbatem primaeue deconsae
tate sibi asciuit. atq; sp̄ssc̄i
ardore adregendam mona
chicam prae elegit cateruam
AMEN

Sicq; cor uestrum irradiet. ut ea
quae indomodi exhuius uita
patroni recitantur. uiscerabi
liter intelligatis. & intelligen
do quantocius imitari possi
tis. AMEN.

Quatinus eius exemplis erudita.
necnon & suffragiis munita.
momentum labentis aeui
transeatis illesi. atq; inaeterna
requiae illi cum palma gloriae
ualeatis adiungi. AMEN

Quod ipse prestare dignetur.
cuius regnum & imperium.
sine fine perman& in saecula
saeculorum. AMEN
Benedictio di patris. & filii.
& sps sci. & pax eius sit semper
uobiscum. AMEN
BENEDICTIO IN NATALE
SCI LAURENTII MAR

Sacrae trinitatis su
per uos benedictio de
scendat gnrosissima.
qui beati leuitae Lauren
tii martirisq: gloriosi festum.
mente celebratis deuotissima.
AMEN
Illius mereamini suffragiis ful
ciri. exemploq: roborari. qui
nec seuitia torquentiu frangi.

nec inmanissima tormentoru[m]
crudelitate · agloriosissima
x[pi] confessione potuit labi·
A M E N
Et qui eum superato diuerso
tormentorum genere · caeles
tem gloriam felici dedit scan
dere cum triumpho · ipse uobis
concedat uigore fidei uitioru[m]
pellere contagia · &cum electis
omnib[us] super indui inmarces
cibilis gloriae coronam·
A M E N
quod ipse prestare dignetur
cuius regnum &imperium·
sine fine permane[t] insaecula
saeculorum·
A M E N

102

DS QVI PER
BEATAE
MARIE VIRGI
NIS PARTU

genus humanum dignatus
est redimere. suauos dignetur
benedictione locupletari.
AMEN.
Eiusq; semper &ubiq; patrocinia
sentiatis. excuius intemerato
utero auctorem uitae suscipere
meruistis. AMEN
Etqui ad eius celebrandam festi
uitatem hodierna die deuotis
mentibus conuenistis. spiritua
lium gaudiorum. &aeternorum
premiorum uobiscum munera
reportetis. AMEN.
Quod ipse prestare dignetur.
cuius regnum &imperium.
sine fine permanet insaecula
saeculorum. AMEN

Benedictio in natale sci Bartholomei apli.

Ds qui eccl̄am tuā in apostolicas tribuisti consistere fundamentis. qs ut beatus bartholomeus pro nobis imploret apostolus. ut annis reatib; absoluti. a cunctis & iam periculis exuamur. AMEN

Infunde sensib; nr̄is apostoli re ianere dogmata. quibus te contemplemur mente serena. AM

Concede propitius circumstanti plebi. ut in illo tremendo discussionis tempore eorum defensetur presidio. quorum est edocta precepto. AMEN.

quod ipse praestare · BENDICT
DE PASSIONE SCI IOHAN
NIS BAPTISTAE
DS qui uos beati
iohannis baptistae
concedit sollempnia
frequentare · tribuat
uobis eadem deuotis mentib;
celebrare · & suae benedictionis
dona percipere : AMEN
Et qui pro legis eius praeconio
carceralib; est retru sus in tene
bris · intercessione sua a tenebroso
rum operum uos liber & incentauis ·
AMEN
Et qui pro ueritate quae ds est
caput non est cunctatus amit
tere · suo inter aduentu · ad ca
put omnium quod xps est uos

faciat peruenire: AMEN
Quod ipse prestare dignetur.
cuius regnum & imperium
sine fine perman& in saecula
saeculorum · AMEN

ITEM ALIA BENO
Dne rege corda
plebis tuae per arma
iustitiae. ut te adtente
diligens. fugiat lasciui
as carnis iniquae · AMEN
Absolue culpas eius obtentu bap
tistae tui iohannis. qui prote
interemptus in ergastulo. tecu
exultat in regno · AMEN
Sitq; apud te intercessor pro po
pulo. quem exequasti heliae
meritis. & inter cunctos sobo

les mundiales. AMEN.

Quod ipse prastare dignetur
cuius regnum & imperium
sine fine permanet
in saecula saeculorum
AMEN.

Benedictio di patris. & filii.
& spi sci. & pax eius sit
semper uobiscum.

suppliciter exoramus · ut qui
exgentibus scam ecclesiam fe
cundauit in grege · ab omni ea
gentilitatis absoluat errore·
 A M E N
Custodi eam adm serpentis incur
su pietate solita · ut tuo famula
tu semper possit esse continua·
 A M E N
Et qui hac die natiuitatem sanctis
simae uirginitatis tuae genitri
cis mariae celebramus deuoti·
eiusdem nos suffragiis post ab
iectam carnis sarcinam · ad ae
terna iubeas regna perduci·
 A M E N
Quod ipse praestare dignetur·

BEŃDIN EXALTATIONE SCAE CRUCIS

D̄S qui redemisti genus humanum per beatae crucis pa tibulum · ut quod prius erat scelestis ad paenam · sit con uersis redempsis aduitam · con cede plebi tuae eius saluari praesidio · cuius est armata uexillo :

A M E N

Sit ea crux fidei fundamentum · spei suffragium · in aduersis de fensio · in prosperis iuuamentum

A M E N

Perseuerætq; in hoste uictoria · in ciuitate concordia · in campo custodia · in domo fultura · ut gregem in futuro conseruet in co

lumen · quae nobis agnouin
cente uersa est in salutem · a͞m
Quod ipse prestare ·

BENĎ IN NATL̅ SC̅I MA THEI APOSTOLI ·

Benedic d͠ne populū
tuum interueniente
matheo ap̅lo · & deuotū
respice humilitatem uide ·
gemitus respice · dolentes pater
na pietate iube consolari · a͞m
Prostratum alleua · dispersum con
grega · adunatumq; conserua ·
esurientem ciba · sitientem pota ·
omnesq; simul caelestib; donis
irriga · dele in eis omnem peccati
maculam · ut te gubernante ad
gloriam peruenianti sempiter
nam · AMEN ·

humiliata tibi omnium capita
dexterȩ tuae benedictione sčifica
ac benedicendo peccata relaxa.
sčiq: spš infunde carismata. ut
sine ulla offensione maiestatis tuae
precepta adimpleant. & aduitā
aeternam teauxiliante perue
niant. AMEN.
Quod ipse prestare SABBATO
MENSE SEPTIMI;
Benedictionū suarū
sup uos dñs imbrem infun
dat. & orationes uras ex
audiat. AMEN
Thesauros misericordiae uobis a
periat. & desideriorum urorum
uota suscipiat. quod perit requi
rat. & uobis quod bonum est
tribuat. AMEN

MUL
PLICIVS
ONS BENEDIC
TIONE LO
CUPLETET.

qui sollempnitate principis
archangelorum mundi gaudia
infert. AMEN.

Et qui deuicto hodierna die hoste
antiquo triumphat. suo inter
uentu molimina eiusdem dra
conis superare uos faciat.
AMEN

Quatinus de animabus uestris
caelestia lucra reportet. & hym
nidias angelorum choris. per
petua uos exultatione consoci
&. AMEN

Quod ipse praestare dignetur.
cuius regnum & imperium.
sine fine permanet in saecula
saeculorum. AMEN

ITEM ALIA BENEDICT

Benedicat uos prin
cipium lucis angeloru̅ .
quos sibi conciues & con
sortes fecit in sedibus
supernorum · AMEN
Quorum amministratione mu
niatur in terris uita uixi · & libe
rata ab hostib; uisibilib; & inui
sibilibus · mereamini peruenire
ad premia aeterna · AMEN
Inter quorum uenerationē ar
changeli michahelis suffulti
auxiliis · cuius memoriam cele
bratis hodie deuotissime in ar
uis · ut illius societate fruamini
in astris · AMEN
Quod ipse prestare dignetur ·

BENEDICTIO IN SOLLEMP

OMNIUM SCORUM·

OMPS DNS
laus & uicto
ria scorum·
qui per mariae
uirginis partum
triumphaliter genus redemit
humanū· benedicere uos digne
tur suffragiis omnium scorum· Am
quiq; apostolorum fidei dogmate·
martyrum sanguinis effusione
scorum patrum operis exhibiti
one· ac uirginum castitatis a
more· scam ecclesiam flore
uirtutum perornat· corda ura
ad eorum exempla uigilanter
accendat· AMEN
Ut sicut hodierna die generaliter

omnium scōrum sollempnitate
congratulamini. ita cum fructu
boni operis perpetualiter eorū
societati valeatis adiungi. Amē
Quod ipse prestare.
ITEM ALIA BENO
Benedicat vos omps ds.
per omnium scōrum
gloriosissimam inter
cessionem. & uincempla
cadissime dignetur susci
pere humillimam benedictio
nem. AMEN
Et quorum interris corde sincero
felicissimū celebratis triumphū.
ipsis opitulantib; ad eorum
in caelis perduci mereamini de
siderabile consortium. Amē
Quatinus terreni contagii macu

lis emundati · ac uirtutum om-
nium radiantib; lampadibus
exornati · & cælestib; coniungi
decenter agminibus · & uenien-
te sponso · ualeatis occurrere
cum bonorum operum fulgen-
tibus luminaribus · AMEN
Quod ipse præstare ·

BENED IN NATL SCI MAR-
TINI EPISCOPI ·
DS qui praesulem
tuum martinum
ita praedestinasti ·
ut eum tuae gratiae
perhenniter iuberes adstringi ·
erige uota populi · qui praetu-
listi glorioso merita confessori ·
AMEN
Proficiat his ad fructum · quicquid

in sacerdote pro laude tui nomi
nis amplectantur. AMEN
Eteius intercessione plebs haec
consequatur ueniam. qui te re
munerante felici seruitio perue
nit ad palmam. AMEN
Quod ipse prestare epi

BEN CO IN NT SCI MARTINI

Ds qui beatissimum prae
sulem tuum martinū
tanta tibi familiarita
te iunxisti. ut etiam
cum adhuc corpore habi
taret in terris. iam tunc corde
totus esset in caelis. dignare eius
intercessione plebem tuam. il
las petitiones effundere. quas
eligas libenter implere. AM

Et festiuitatem hanc uenisse bene

ficiis internis sentiant . quam
uidere uultus uouis incaelis op
tant· AMEN
Sit ipse confessor huius populi .
assiduus custos . qui te uocante
hodie penetrauit caelos ·
Quod ipse · AMEN
BEN INN NT SCE CECILIAE VIRG

SOLLEMNITATIS
super uos descendat
benedictio gratissima .
qui beatae caeciliae uir
ginis martirisq; suae festiuita
tem celebratis mente deuotissi
ma· AMEN
Illius mereamini suffragiis ful
ciri . eiusq; auxilio roborari .
qui nec saeuitia torquentium

frangi · nec inmanissima tor
mentorum crudelitate · ac glo
riosissima xpi confessione po
tuit auerti : AMEN
Et qui eam superato diuerso tor
mentorum genere · caelestem
ad gloriam fecit cum triumpho
scandere · ipse uos concedat ui
gore fidei uitiorum contagia
pellere · & cum electis omnibus
indui inmarcescibilis corona
gloriae : AMEN
Quod ipse :

BENEDICTIO IN NAT
SCI CLEMENTIS · EPI
DMS UESTRORUM
cordium archana
purificet · & benedictio
nis suae uobis tribuat incrementa ·

qui hodierna die sci clementis
festiuitatem deuote uobis conce
dit celebrare: AMEN
Abomnib; eius intercessionibus
uitae praesentis periculis exua
mini . & uirtutum spiritalium
ornamentis induamini. AMEN
Quo illius adiutorio fulti sic dno
seruiatis in terris · ut ei coniungi
ualeatis in caelis: AMEN
Quod ipse · BENEDICTIO · IN
 uigl̄ sc̄i andreae apl̄i.
OMPS dōs. suauos bene
dictione locuplet&
qui beatū andream
apostolicae dignita
tis praeconio sublima
uit. AMEN
Concedatq; uobis ipsum habere

intercessorem in caelis. cuius de
uote praeuenitis interris diem
sollempnitatis. AMEN
Ipsius quoq; interuentu queatis
scandere alta caelorum. quo
praecessit idem per crucis pas
sionem sequendo dnm magis
trum. AMEN
Quod ipse.

Item in die. Ben
DS qui beatum andreā
aptm per passione
crucis ad sedes euexit
aethereas. ipse uobis
tribuat bonorum operum eun
dem sequi uestigiis. AMEN
Et quem peculiarem optinere me
ruistis patronum. ad caelestae
ipso intercedente ualeatis felicē

perangere regnum. AMEN
Eundemq; mereamini uidere
in caelis regnantem. cuius gra
tulanter celebratis sollempnis
simum diem. AMEN
Quod ipse:
ITEM ALIA.
Dne dm omps qui glorio
sus super sidera sedens
almum nobis sidus
beatos apostolos reliquis
ti. quorum speciosam cohortē
felici claritate pollentem. prius
prae elegisti merito. ut prae
destinares in regno. AMĒ
Concede propitius circumstanti
plebi crucis tuae muneris signa
culum. ut uniuersum super&.
aduersae potestatis incursum

Adiuua & familiam tuam tibi dne supplicando uenerandus andreas apostolus. & pius interuentor efficiatur. qui tui nominis extitit praedicator: AMEN

Infunde sensibus eius apostolica dogmata. quo te contemplemur. mente serena: AMEN

Ut in illo tremendo discussionis tempore. eius defensetur praesidio. cuius est secuta praeceptum. AMEN

Quod ipse. BENEDICTIO IN NT̄E SCI THOMAE APLI

Custodi qs dn̄e gregem tuum. quem congregare dignatus es. ut per interces

sionem beati thomae aposto
li. nullus retrorsum ruat. nul
lus post diabolum reuertatur.
A m e n
Sed omnes tua uirtute protecta.
uitam aeternam consequi me
reantur. A m e n
Ut tecum regnantes in perpetuo.
ubi est cum aeterno patre. &
spū sċō. honor & gloria. in sae
cula saeculorum. A m
q̇od ipse.

IN NATLE UNIUS APTI

Ds qui uos in a
postolicas tribuit
consistere fundam
tis · benedicere uos dig
netur · beati apli sui · ill · inter
cedentib; meritis · AMEN
Defendatq; uos a cunctis aduersis
apostolicis praesidiis · qui uos
eorum uoluit ornari & mune
rari · exemplis & documentis · AM
Quo p eorum intercessionem p
ueniatis ad aeternae patriae
hereditatem · per quorum doc
trinam teneatis fidei integrita
tem · AMEN
Quod ipse praestare dignetur ·
AMEN

IN NAT̄L UNIUS MAR:

BEATI MARTYRIS SUI
ill· intercessione uos
dn̄s benedicat· & ab
omni malo defendat· am̄
Extendat in uos dexteram suae
propitiationis· qui eum suscepit
per supplicia passionis· am̄
Quo eius in caelo mereamini habe
re consortium· cuius deuotis
mentib: in terra celebratis triū
phum· AMEN
Quod ipse· IN NATALE PLURI
MORUM MARTYRUM·
BENEDICAT UOS DN̄S
beatorum martyrum
suorum· ill· suffragiis
& liberet ab aduersitati
bus cunctis· AMEN

Commendet uos eorum interces
sio gloriosa · quorum inconspec
tu eius est mors pretiosa· Am̅
Et sicut illi per diuersa tormen
torum genera caelestis regni
sortiti sunt hereditatem· ita uos
mereamini eorum consortium
per bonorum operum exhibiti
onem· AMEN
Quod ipse praestare

BENEDICTIO IN NATALE UNIUS CON
FESSORIS EPI

Omnipotens d̅n̅s det uobis co
piam suae benedic
tionis· qui beatum .ill.
sibi adsciuit uirtute confessio
nis· AMEN
Et qui illum fecit coruscare mira
culis· uos exornet bonorum o

perum incrementis: AMEN
Quo actus & exemplis erudita. &
intercessione munita. cuius de
positionis diem celebratis. illi
possitis incaelesti regione ad
iungi. AMEN
Quod ipse præstare: INT plu
RIMORUM CONFESSOR
corum confessorū
suorum. ill. meritis uos
dns faciat benedici. &
contra aduersa omnia
eorum intercessione muniri. am
Eorum uos efficiat suffragio
felices. quorum festiuitatis diem
celebratis ouantes: AMEN
Quo eorum imitantes exempla.
ad caelestia peruenire possitis
promissa: AMEN

Quod ipse· BEND IN NAT UNIU
VIRGINIS NON MART

BENEDICAT
uobis ds·
nri oris alloquio· &
cor uestrum sinceri
amoris copulæ nexu perpetuo·
A M E N
Floreatis rerum præsentium
copiis· iustitia adquisitis· gau
deatis perhenniter fructibus
sinceris simae caritatis· A M
Tribuat uobis ds dona perhennia
interueniente beata ill· uirgi
ne sua· ut post tempora feliciter
dilatata· percipiatis gaudia sem
piterna· A M E N
Quod ipse·

BENO IN NATL UNIUS UIR
GINIS ET MARTYRIS

BENEDICAT UOS DNS.
qui beatae uirgini .ill.
concessit. & decorem uir
ginitatis. & gloriam
passionis. AMEN
Et cuius opitulatione illa meruit
& sexus fragilitatem. & persequen
tium rabiem deuincere. uos pos
sitis & uirorum corporum illece
bras. & antiqui hostis machina
menta superare. AMEN
Quo sicut illa sexu fragili uirile
nisa est certamen adire. & post
certamen de hostib; triumphare.
ita uos in hac mortalitate uiuen
tes: ualeatis & antiquum hostem
deuincere. & ad regna caelestia

peruenire : AMEN
Quod ipse præstare

BENED INNATL PLURIMA
RUM UIRGINUM

OMPS · INTERCE
dentibus scīs uirgi
nibus tuis · uos dig
netur benedicere · qui
de antiquo hoste · non solum per
uiros · uerum etiam p feminas uo
luit triumphare · AMEN
Et qui illis uoluit centesimi fructus
donum decoremq; uirginitatis
& agonem martyrii conferre
uos dignetur & uitiorum sualo
rib; expurgare · & uirtutum lam
padibus exornare · AMEN
Quatinus uirtutum oleo ita pecca
torum urorum lampades possint

repleri · ut cum eis caelestis spon
si thalamum ualeatis ingre
di · quod ipse ·

BEND IN DEDICATIONE ECCLAE.

BENEDICAT ET

custodiat uos omps ds
domumq; hanc sui
muneris praesentia il
lustrare. atq; suae pietatis ocu
los super eam die ac nocte dig
netur aperire. AMEN

Concedatq; propitius ut omis qui
ad decationem huius basilicae
deuote conuenistis. interceden
te beato .ill. & ceteris scis suis.
quorum reliquiae hic pio uene
rantur amore. uobiscum hinc
ueniam peccatoru uvrorum. re
portare ualeatis. AMEN

Quatinus eorum interuentu. ipsi
templum sci sps. in quo scadsm

nitas iugiter habitare dignet
efficiamini. & post huius uitae
labentis excursum. ad gaudia
aeterna feliciter peruenire
mereamini
uod ipse